The Swans of Kensington Garden
A Photo Book of Swans
by Heather Burns

© Heather Burns, 2016, All Rights Reserved

Published by Heather Burns, 2016, in Wexford, Ireland.

No portion of this book, either photographs or text, may be reproduced in any form without express written permission of the publisher.

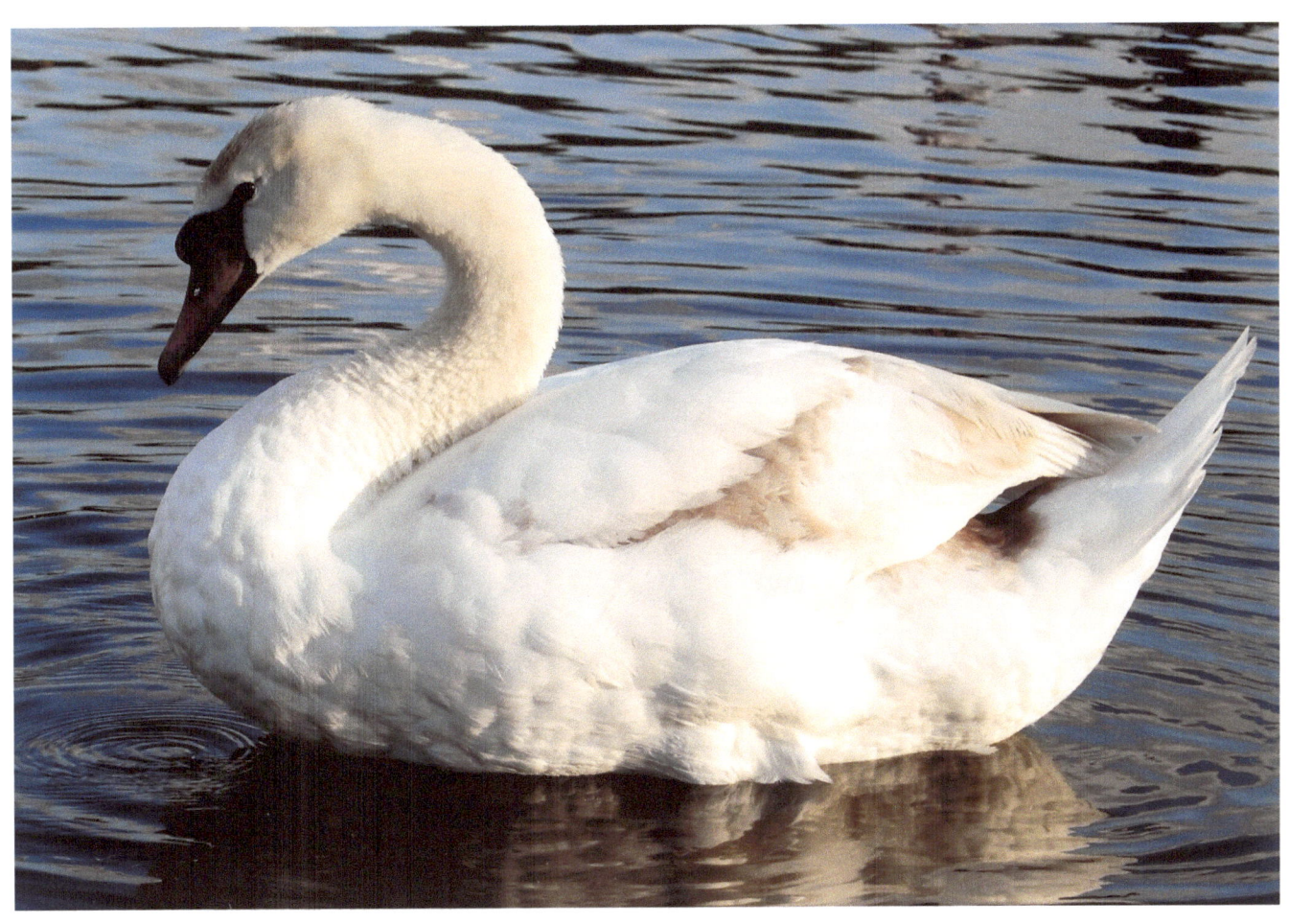

A Cygnet Mute Swan resting on the lake. I love this classic pose. It will lose the Brown feathers when it becomes an adult.

Swans are birds of the family Anatidae within the genus Cygnus. The Swans' close relatives include Geese and Ducks. Swans are grouped with closely related Geese in the subfamily Anserinae where they form the tribe Cygnini. A group of wild Swans is known as a herd, however a group in captivity are called a fleet. A female is a Pen and a male is a Cob. Until they are adults, the young Swans are called Cygnets.

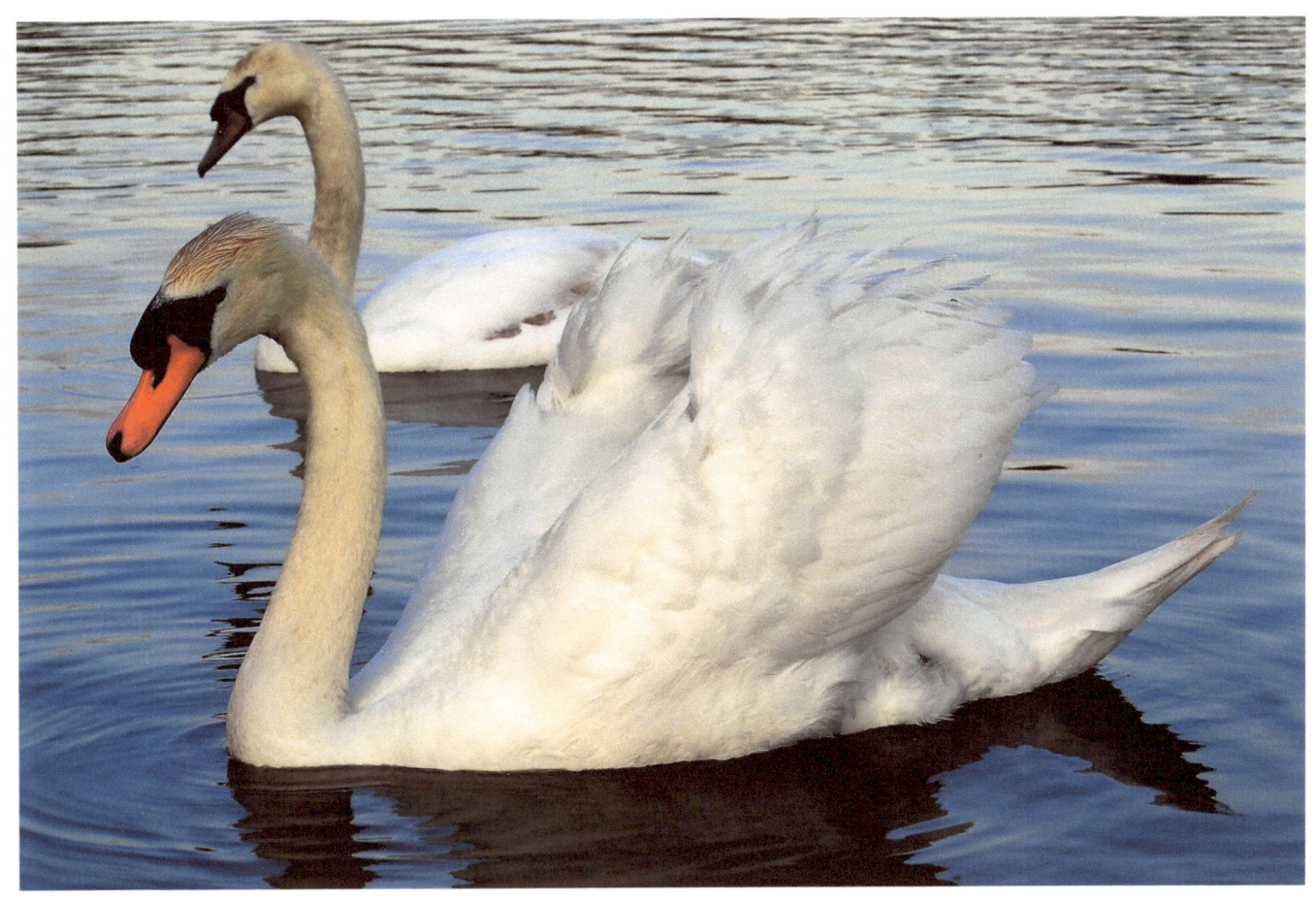

I believe this is a couple. They stayed together all day while I was at the lake taking photos. But the one in back has Brown feathers, so it might be a Cygnet with its parent.

Swans are the largest members of the waterfowl family Anatidae, and are among the largest flying birds. They can reach a length of over 1.5 meters (59 inches) and weigh over 15 kg. (33 lb) Their wingspans can be over 3.1 meters. (10 ft)

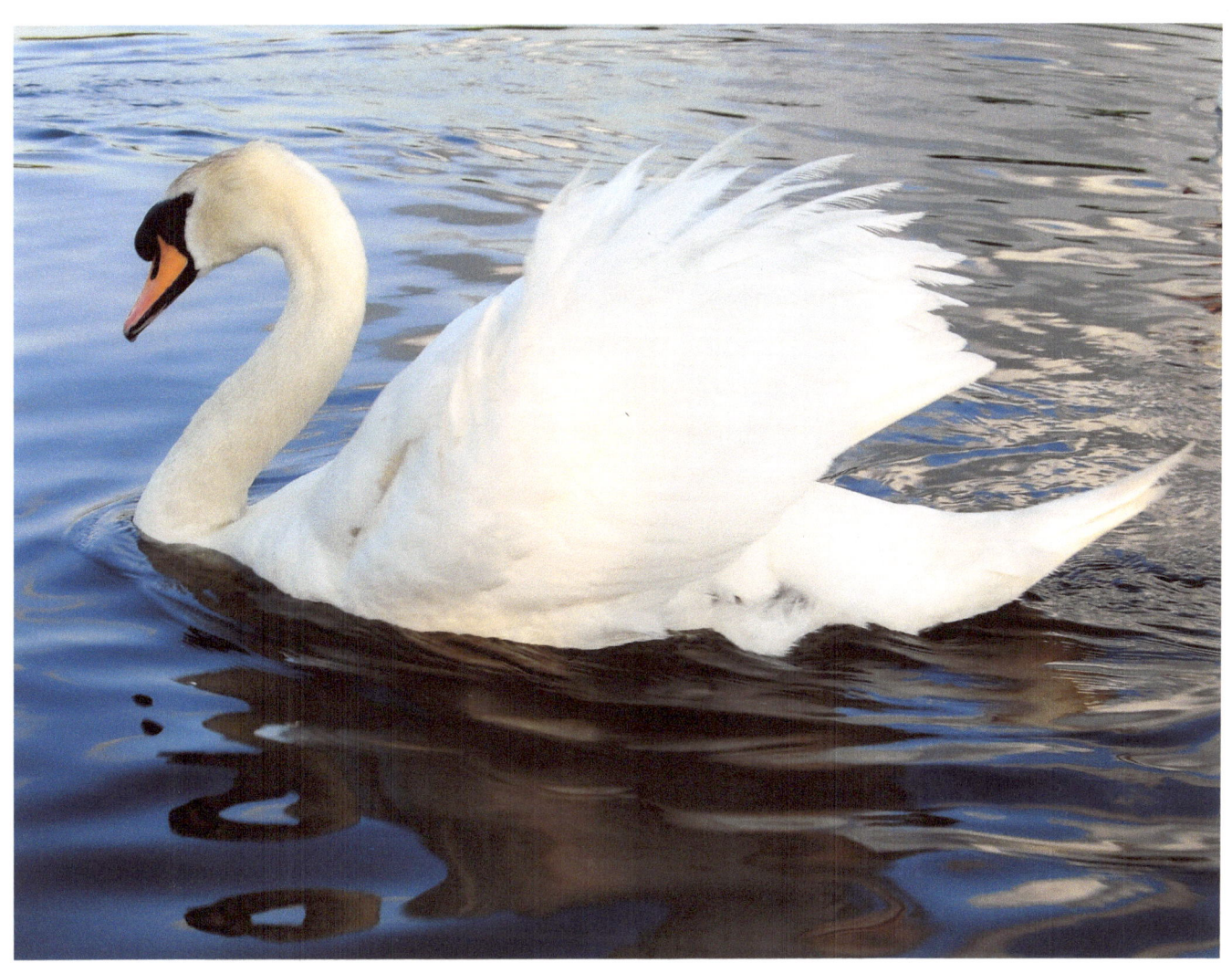

I love this classic pose with the beautiful wings extended and the S curved neck!

There are six or seven species of Swans in the genus Cygnus; in addition there is another species known as the Coscoroba Swan, although this species is no longer considered one of the true Swans. The ones at Kensington Garden are all Mute Swans.

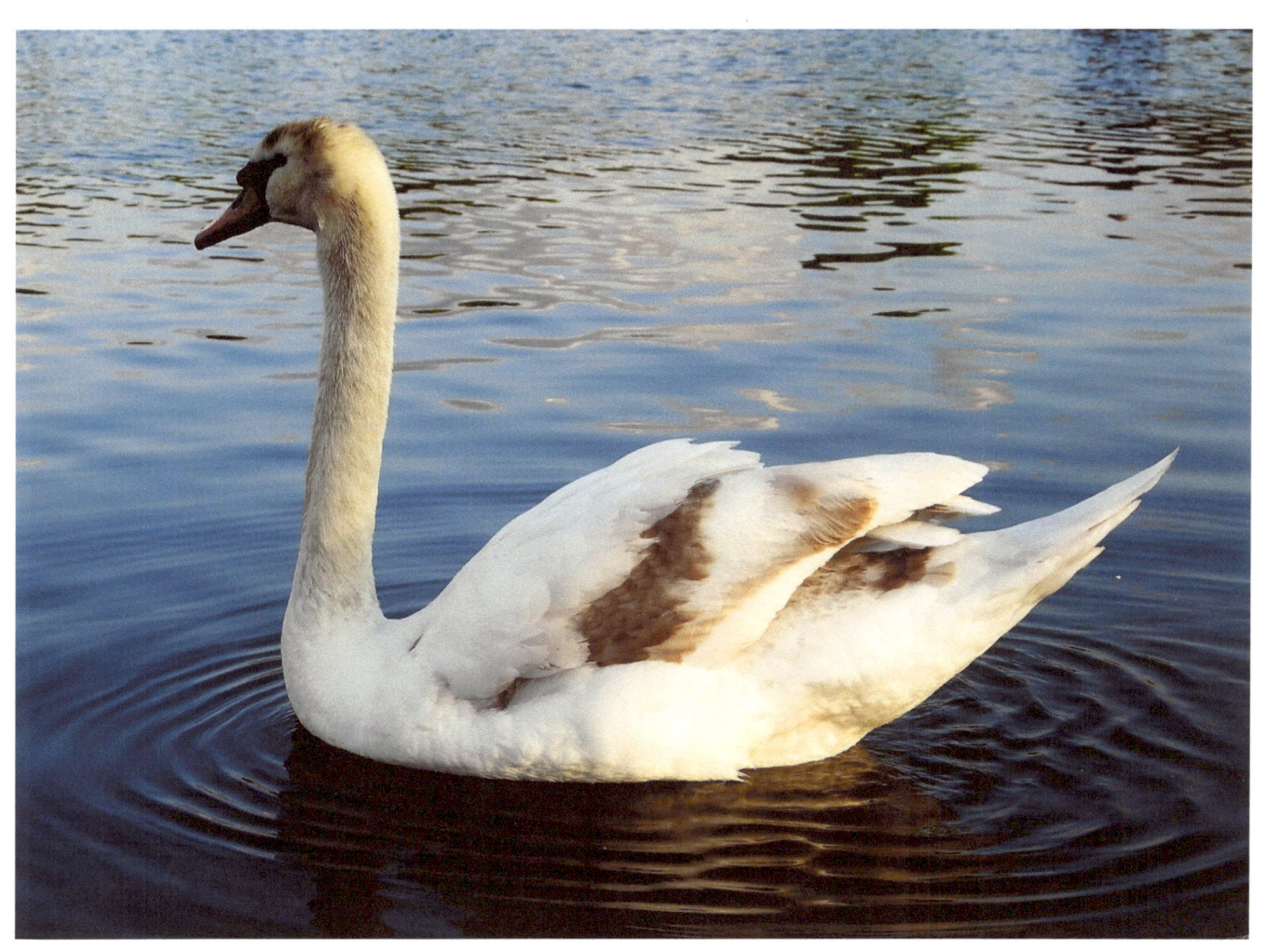

A young one! It hasn't lost its Brown feathers yet.

Swans usually mate for life, though "divorce" does sometimes occur, especially if there is a nesting failure. If a mate dies, the remaining Swan will take up with another, but mostly they are monogamous. Thus, their use in weddings as a symbol of love and devotion.

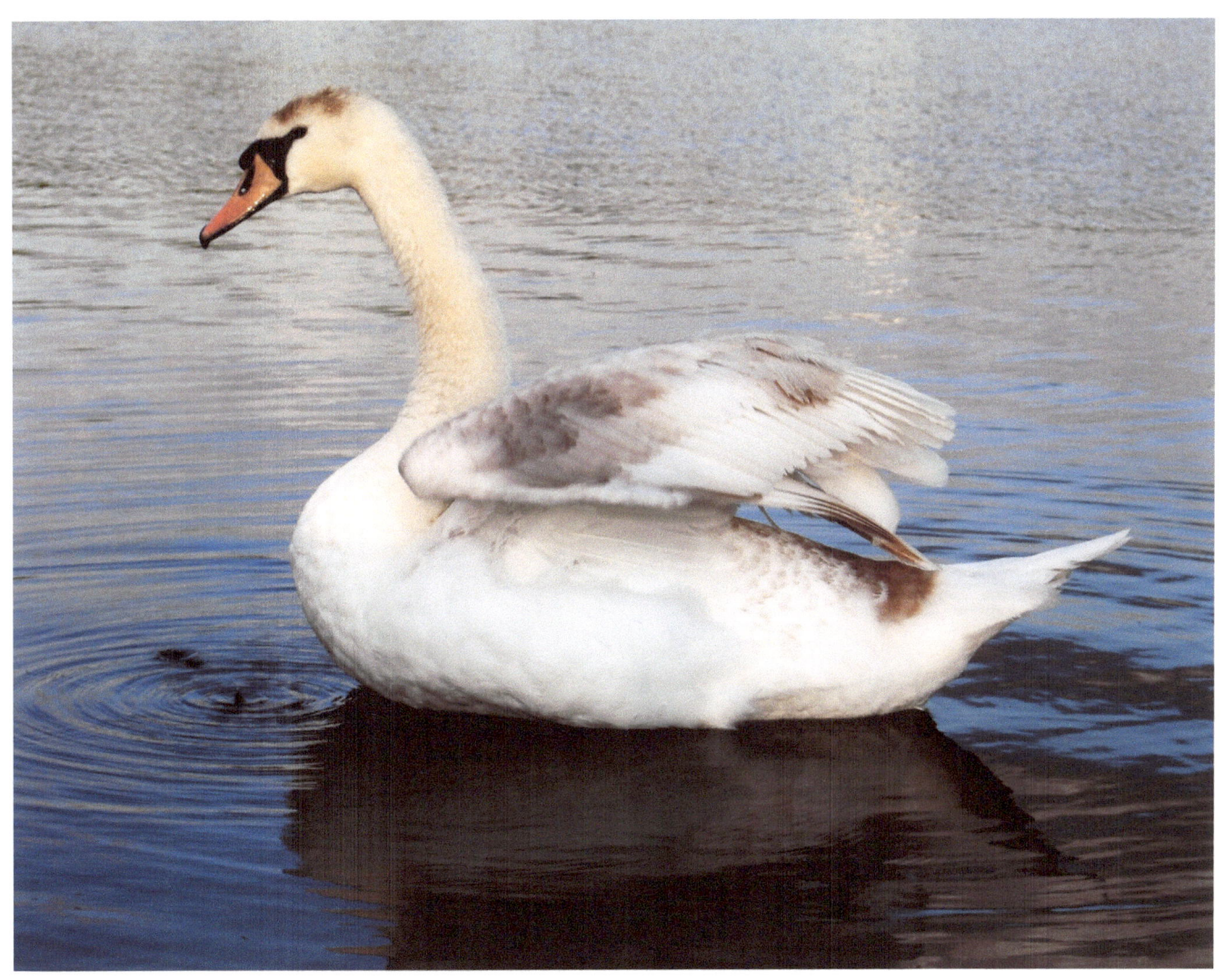

You've heard the phrase, "ruffling feathers," right? It refers to the Swan showing its discomfort by ruffling. This one was showing me its discomfort before moving away.

The genders are alike in plumage, but males are generally bigger and heavier than females. Although Swans only reach sexual maturity between 4 and 7 years of age, they can form socially monogamous pair bonds from as early as 20 months that last for many years or even for life.

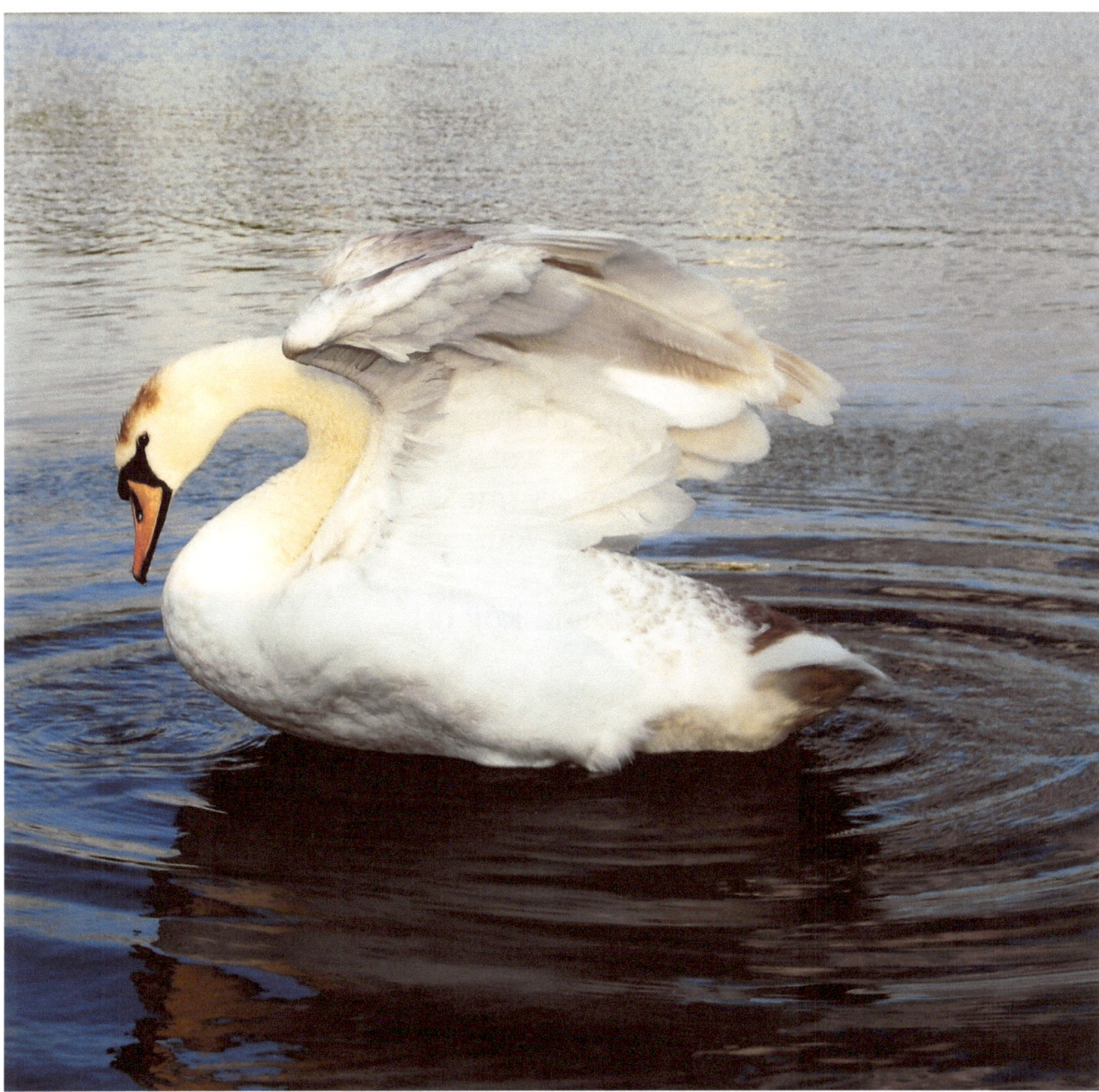

Even when I write about this Swan
and that Orchid,
I write about you.
Every word
of every line
is for you.

~ Kamand Kojouri

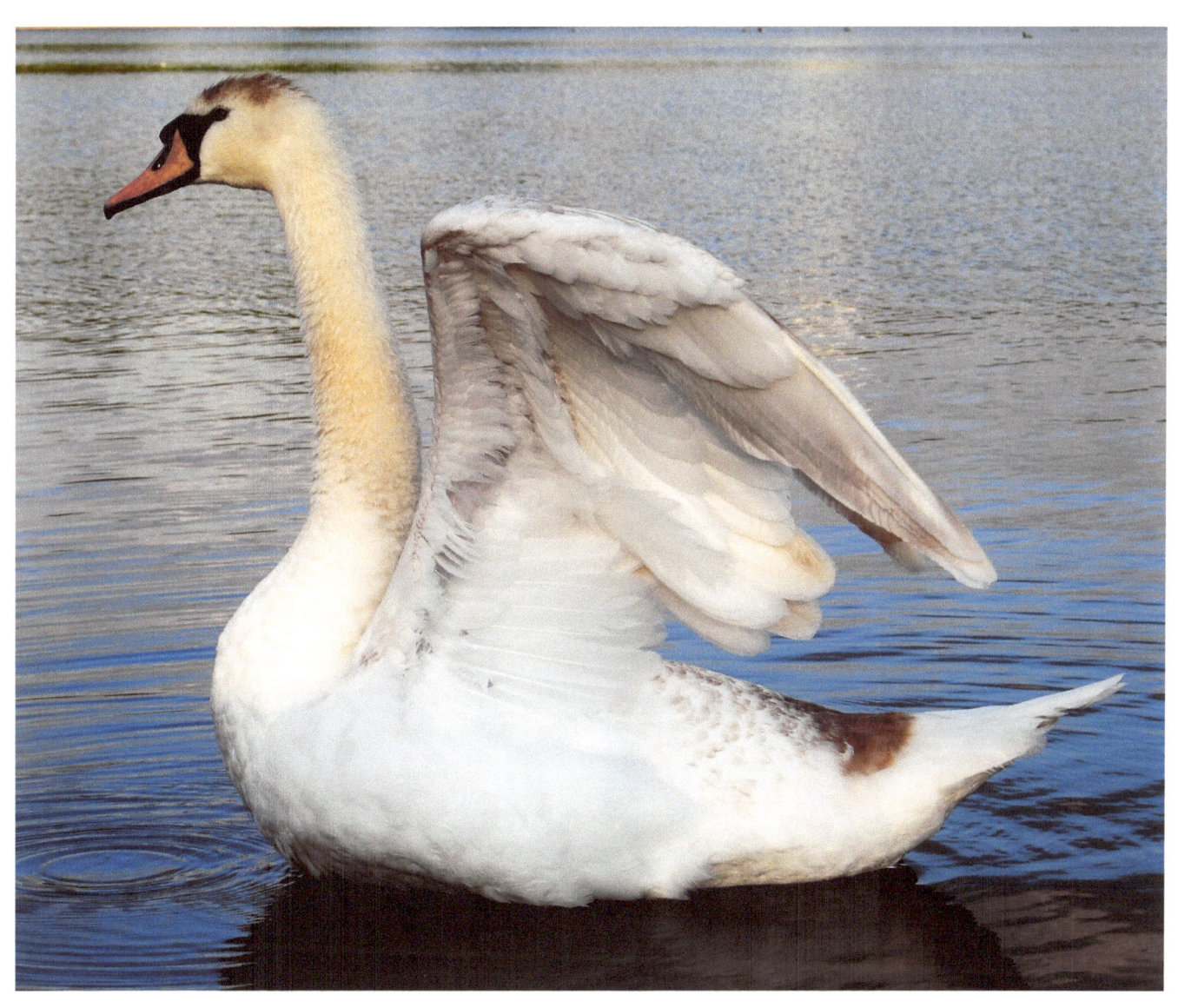

An Angel might be jealous of that wing, do you agree?

Swans are intricately associated with the Divine twins in Indo-European religions, and it is thought that in proto-Indo-European times they were a solar symbol associated with them and the original Indo-European sun Goddess. The sun Goddess as a prototype is descended from both the ancient Egyptians and the ancient Celts.

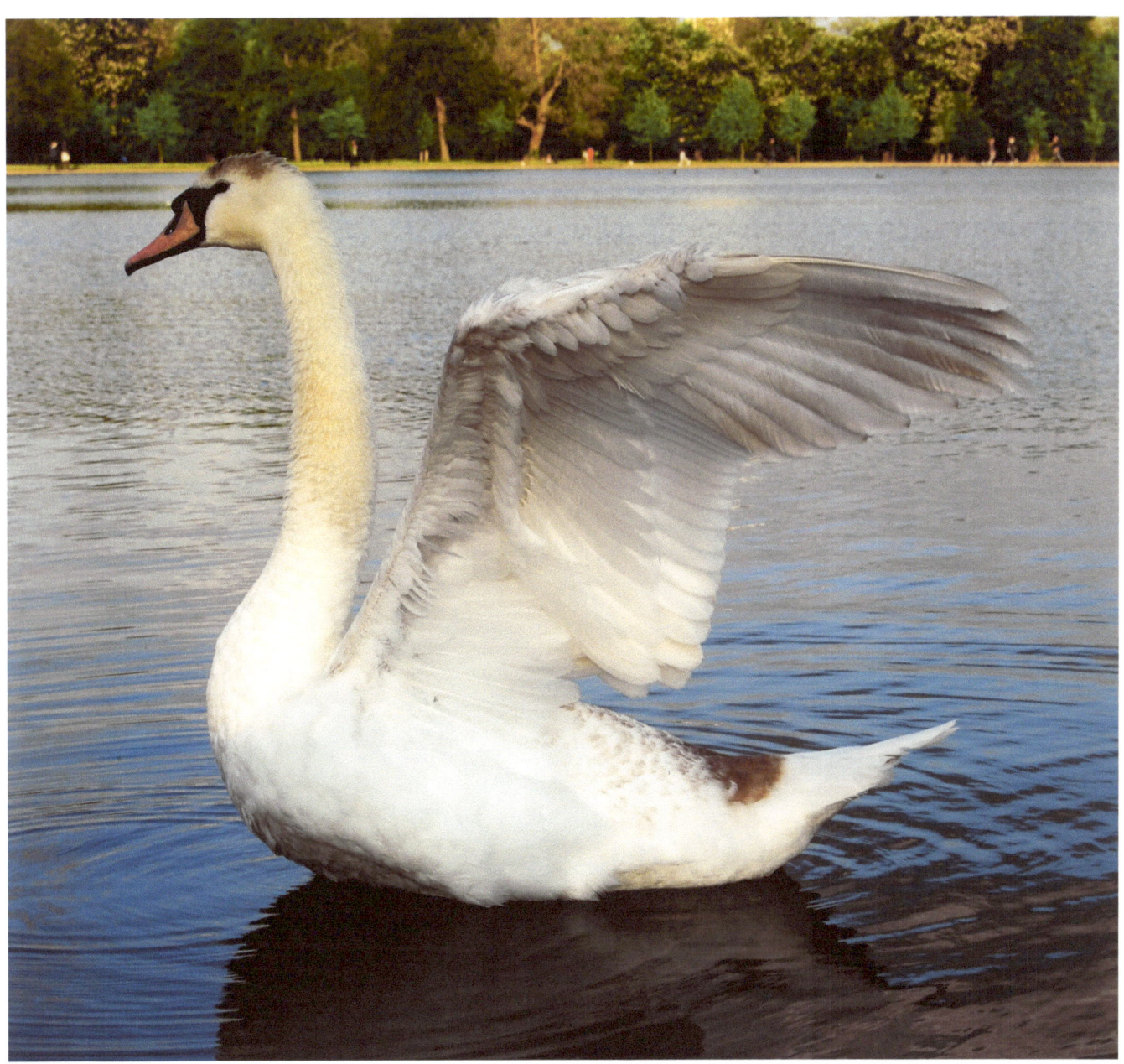

Ripples on the lake,
Feathers leaving their White sides
Swans sigh and take flight.

~H. Burns

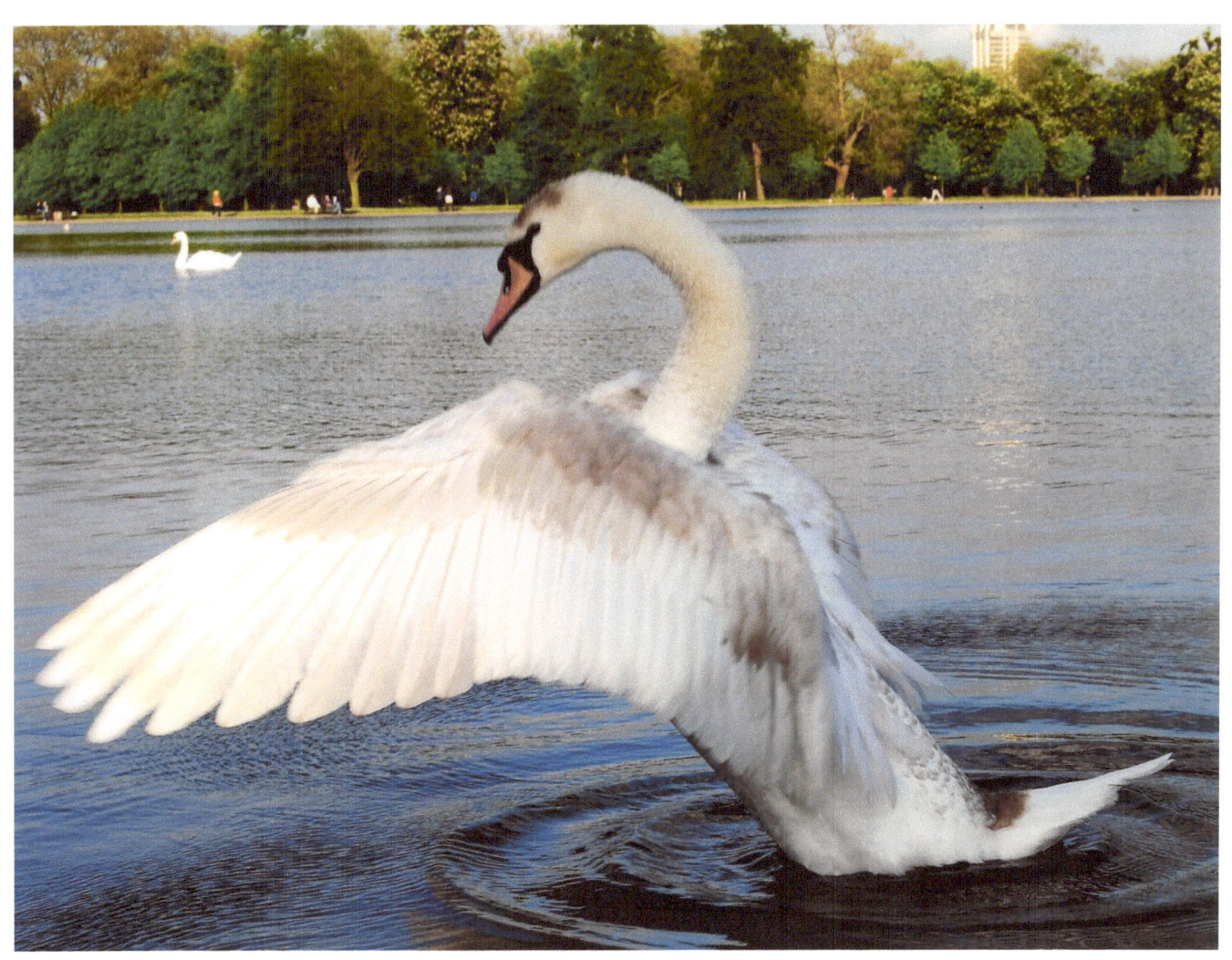

Up, up, and away!

Swans glide majestically when swimming and fly with slow wing beats and with necks outstretched. They migrate in diagonal formation or V-formation at great heights. Despite their size, no other waterfowl moves as fast on the water or in the air.

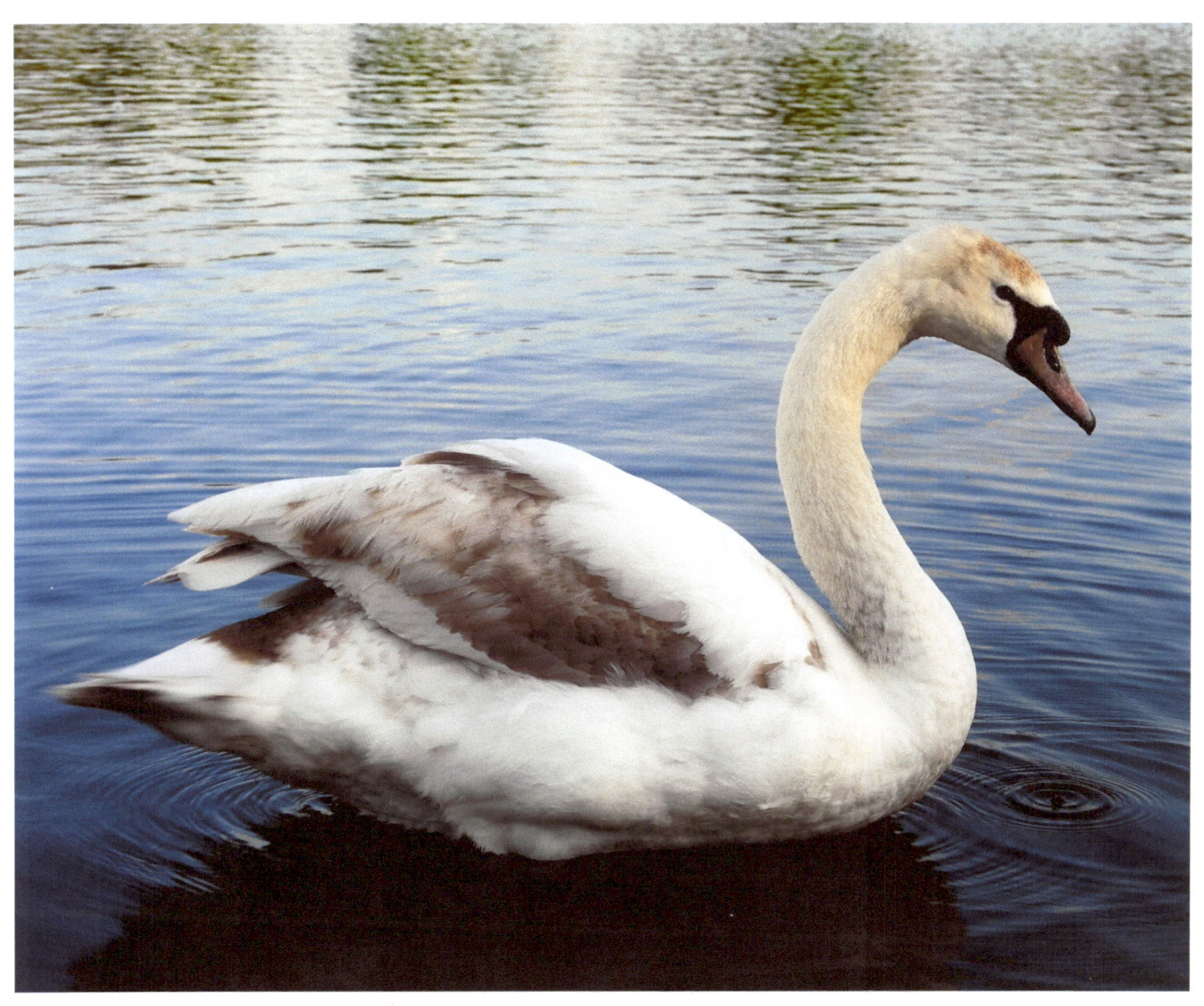

A slight ruffling of the feathers starting here.

The Mute Swan is one of the sacred birds of Apollo, whose association stems from the nature of the bird as a symbol of light. The god is often depicted riding a chariot pulled by or composed of Swans in his ascension from Delos.

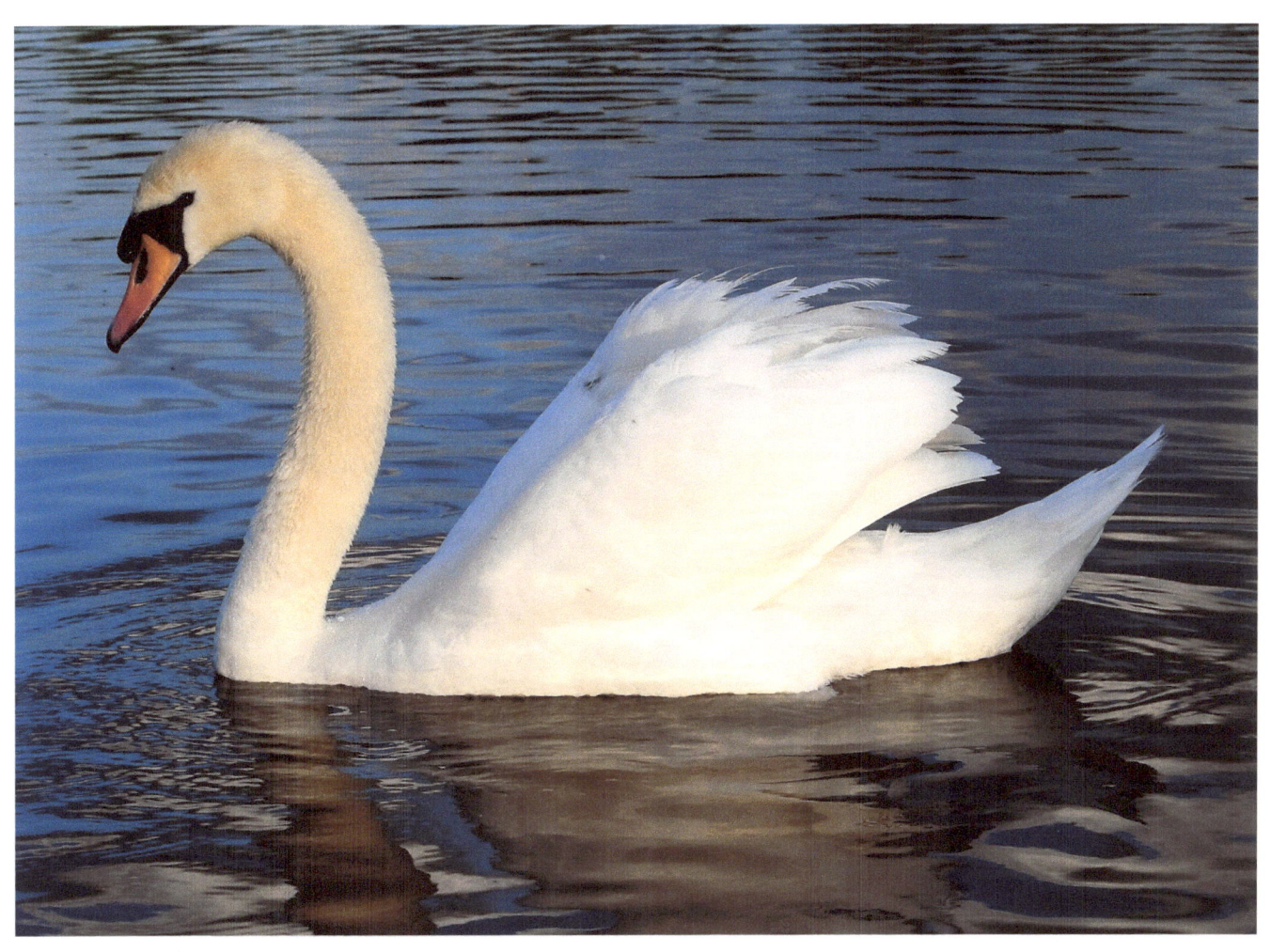

The classic pose. I love how it is looking at me.

Swans feature strongly in mythology. In Greek mythology, the story of Leda and the Swan recounts that Helen of Troy was conceived in a union of Zeus disguised as a Swan and Leda, Queen of Sparta. Other references in classical literature include the belief that upon death the otherwise-silent Mute Swan would sing beautifully—hence the phrase Swan song. That's not really true, but it persists as a myth.

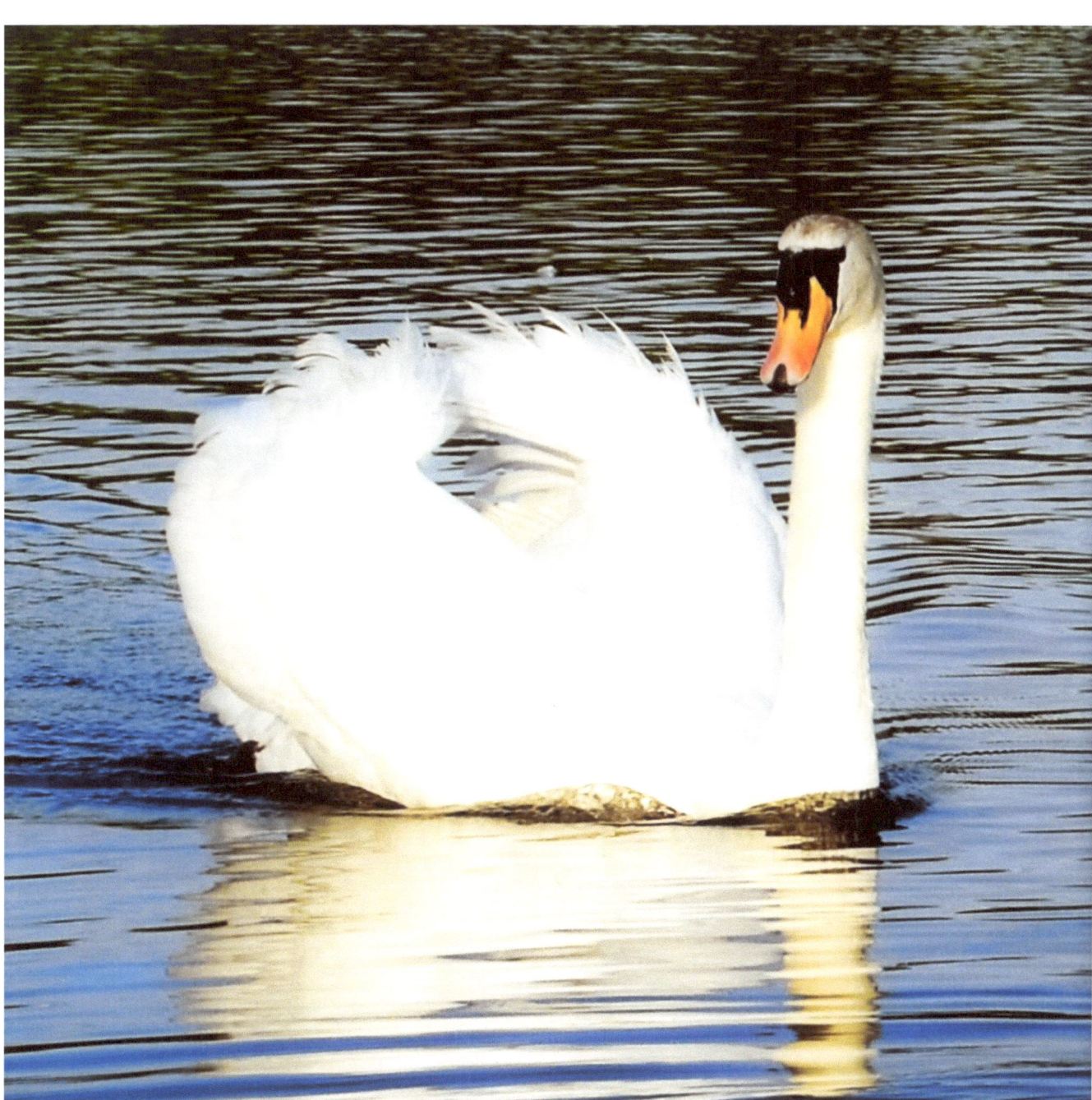

Recent fossil records, according to the British Ornithological Union, show Cygnus olor (the Mute Swan) is among the oldest bird species still existing and it has been upgraded to "native" status in several European countries, since this bird has been found in fossil and bog specimens dating back thousands and thousands of years.

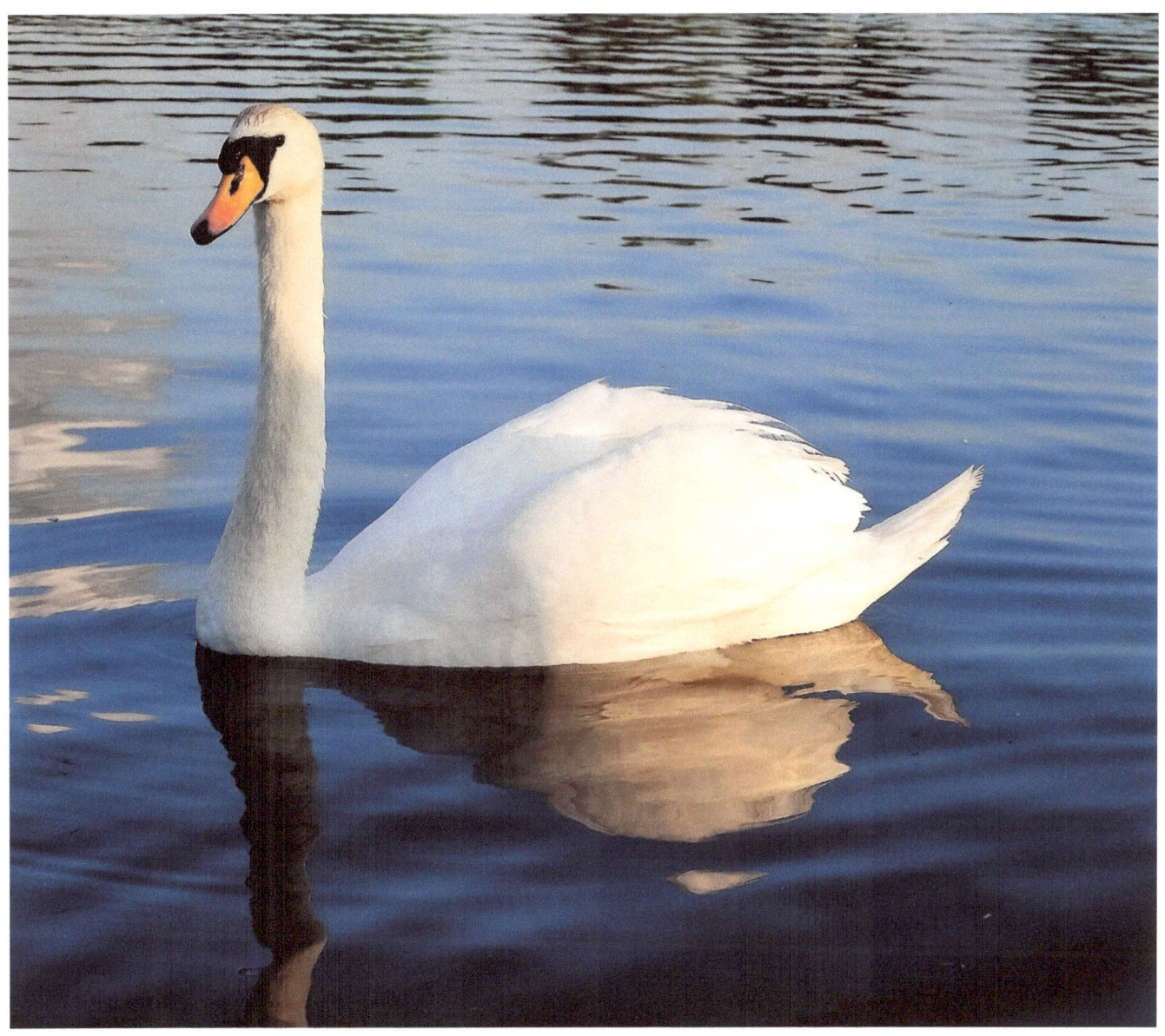

Every lake belongs to the quietness desired by the Swans.

~Munia Khan

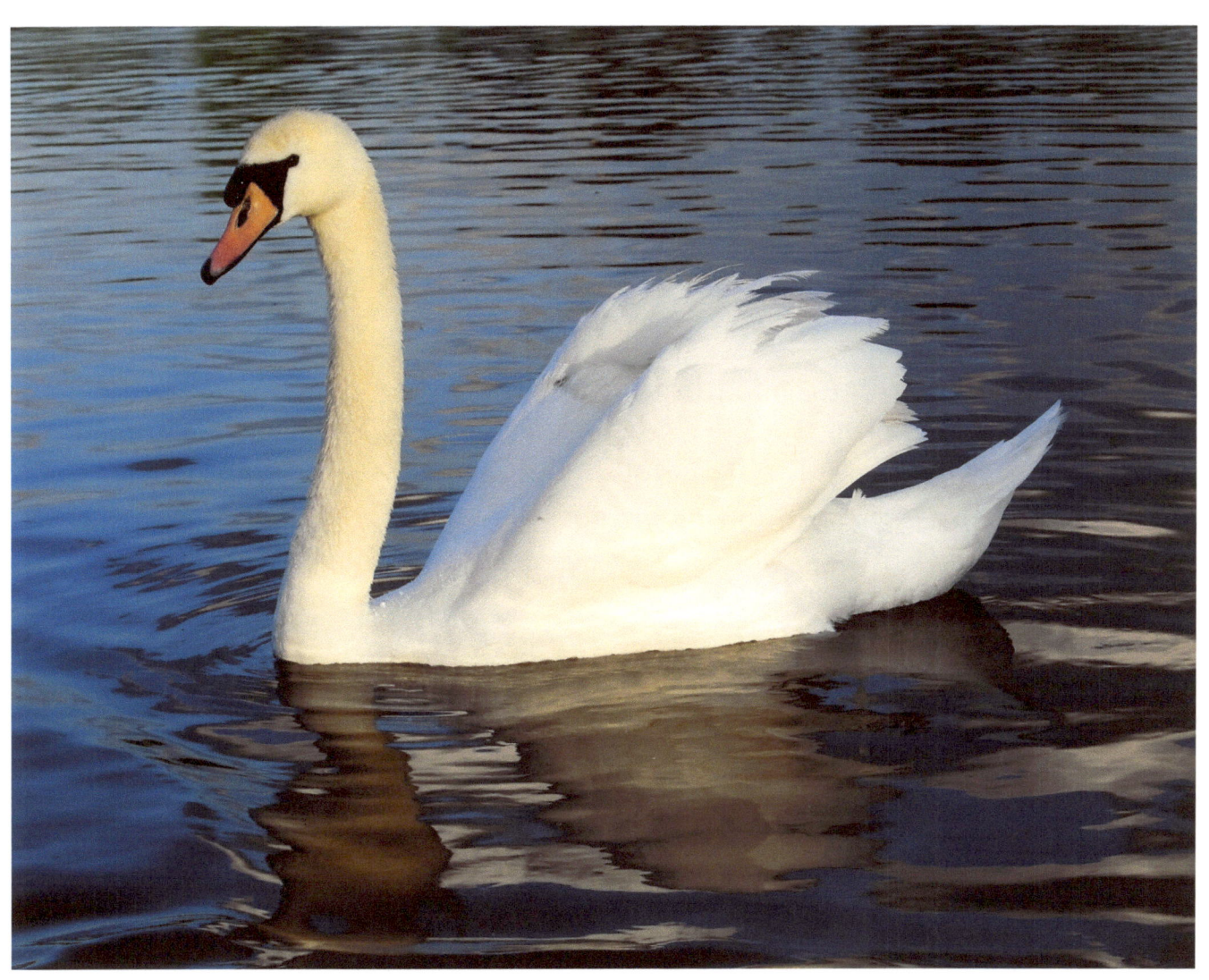

Calm, but watchful...moving a little in the water.

The Swan has over 25000 feathers in its body. They are water resistant, thus keeping the Swan warm even in the cold. They can sleep on either land or the water. They have the option of sleeping while standing on one leg or while floating in the water.

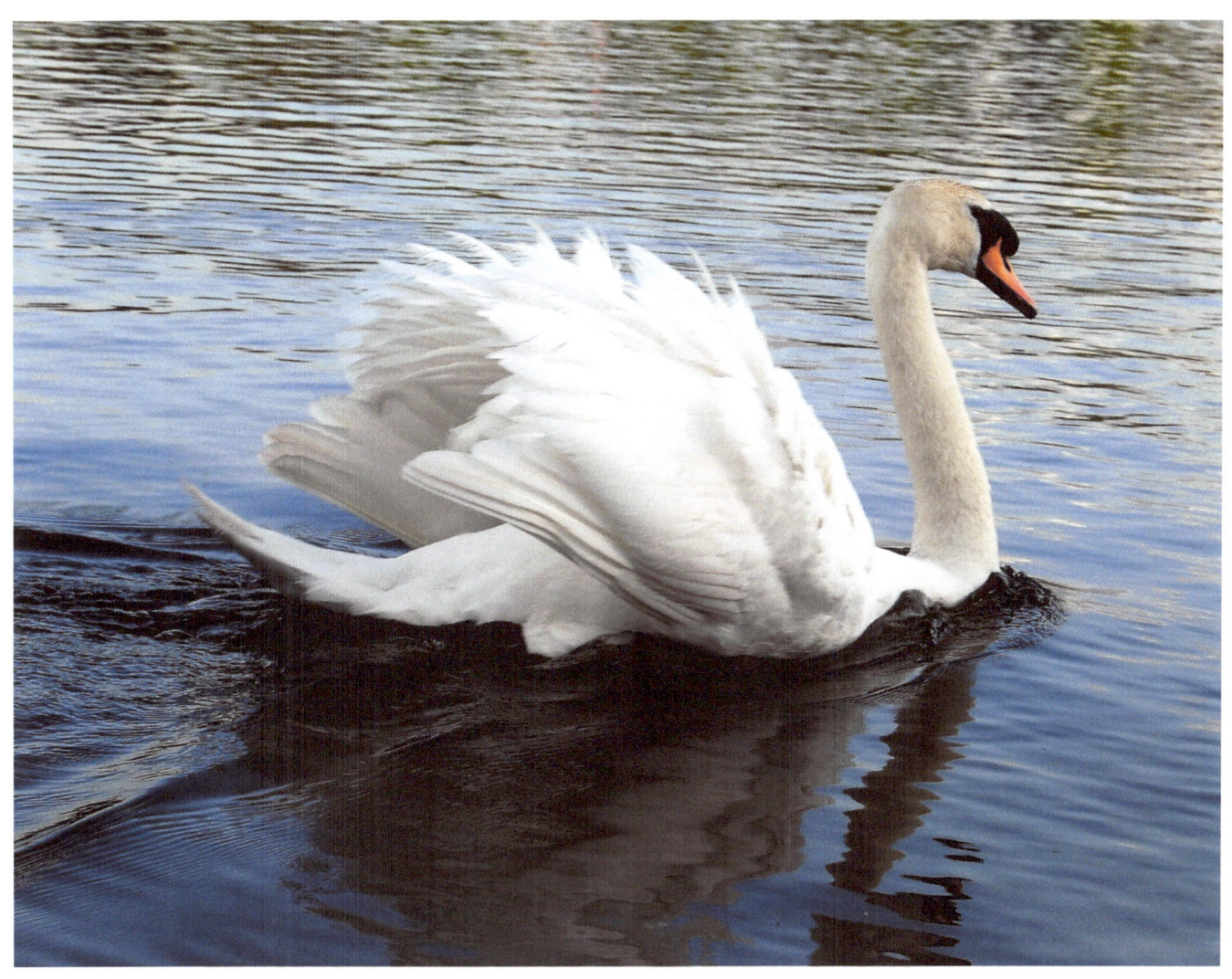

Swimming away! But just look at those beautiful feathers! I was sorry I frightened it until I saw those feathers.

Swans feed in the water and on land. They are almost entirely herbivorous as their diet is composed of aquatic and submerged plants. They may eat small amounts of aquatic animals. Swans typically know their limits when it comes to eating and do not overeat.

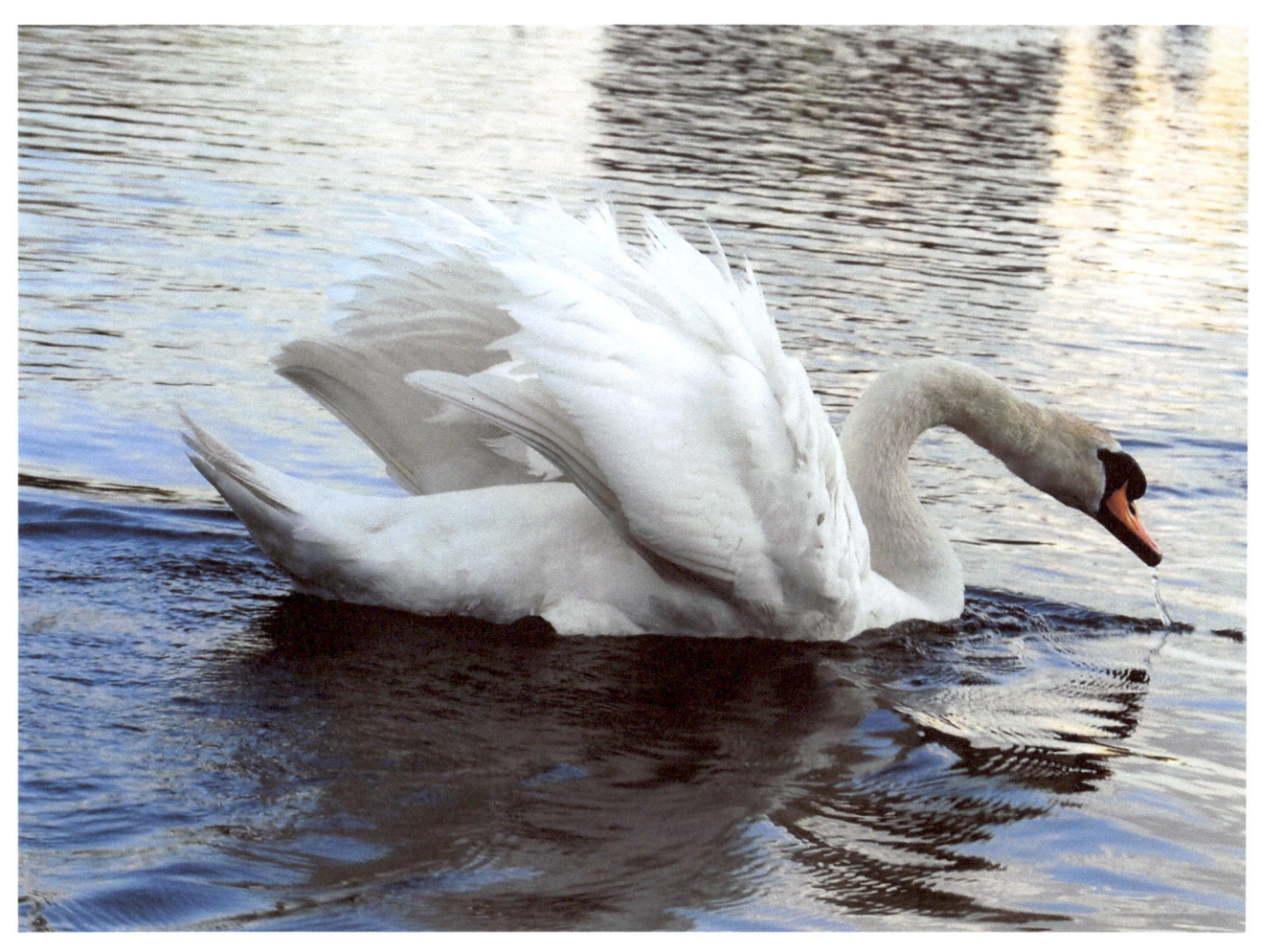

It had to stop for a drink...

The lifespan of the Mute Swan is often over 10 years, and sometimes over 20. They actually live longer in captivity than they live in the wild.

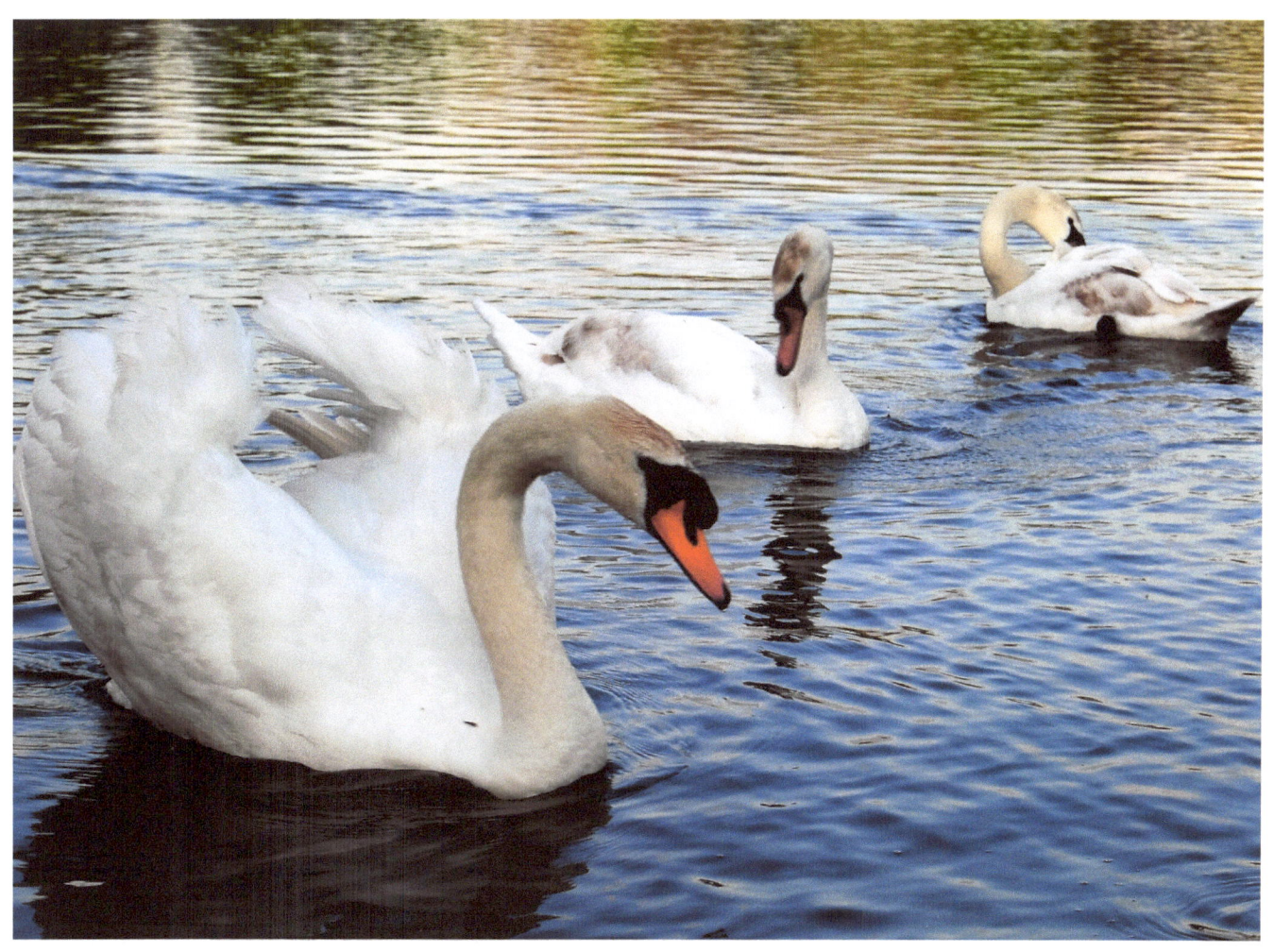

This group of Swans stayed together and might be a family unit. Notice two of them are Cygnets and possibly the front one is the mother.

The Irish legend of the Children of Lir is about a stepmother transforming her children into Swans for 900 years! Only the sound of the new God's bell can restore them, and there is just time to baptise them before they die. Stepmothers have always had a bad reputation, I guess.

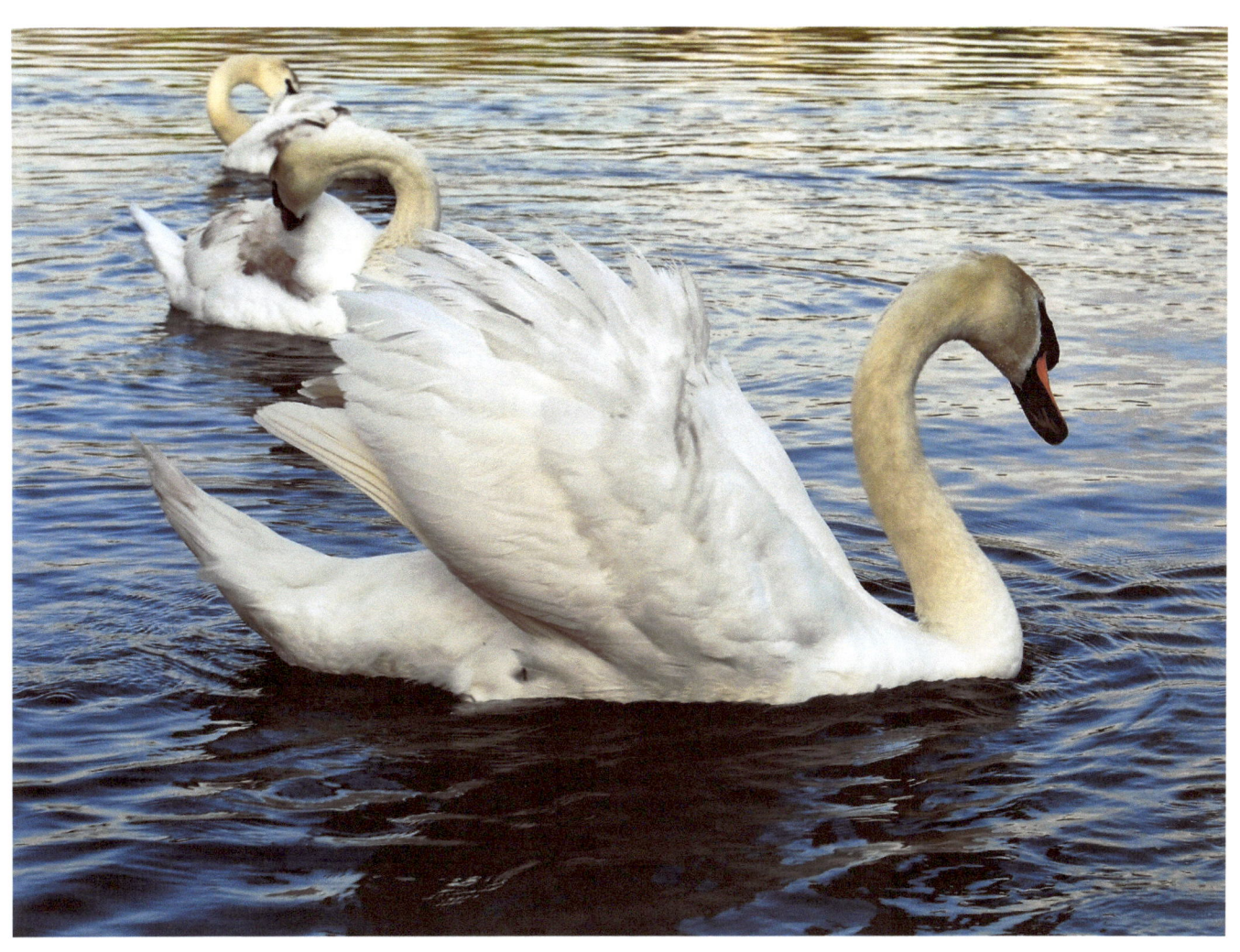

Acrobatic necks!

In another Irish legend The Wooing of Etain, the King of the Sidhe transforms himself and the most beautiful woman in Ireland, Etain, into Swans to escape from the King of Ireland and Ireland's armies.

Swans are part of many Irish legends and the Swan has recently been depicted on an Irish commemorative coin.

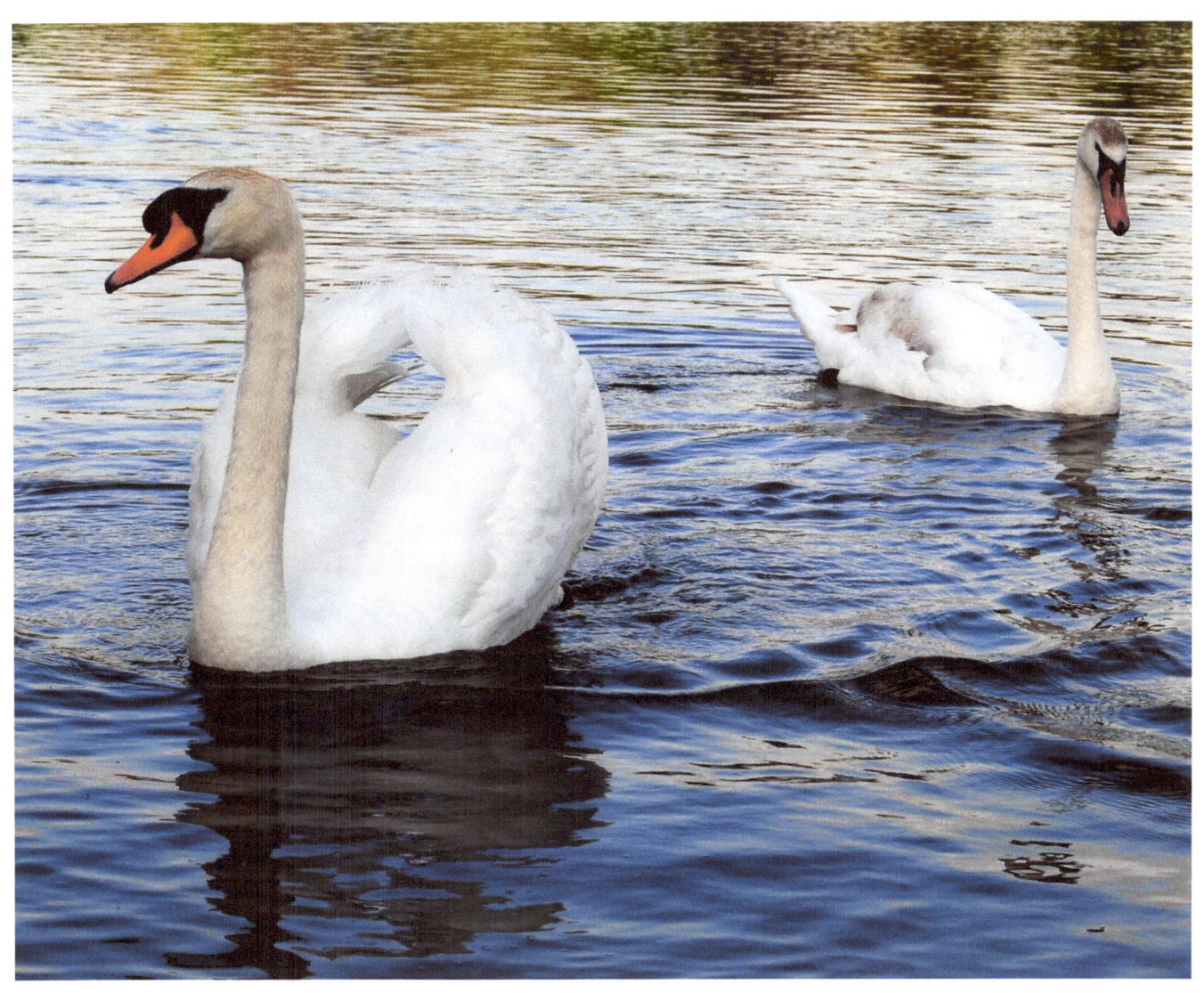

Probably a Pin and her Cygnet

Swans are present in the Irish poetry of W.B. Yeats. "The Wild Swans at Coole" has a heavy focus on the mesmerizing characteristics of the Swan. Yeats also recounts the myth of Leda and the Swan in the poem of the same name. The Irish have many legends and tales about Swans. I have quoted both poems in other parts of this book.

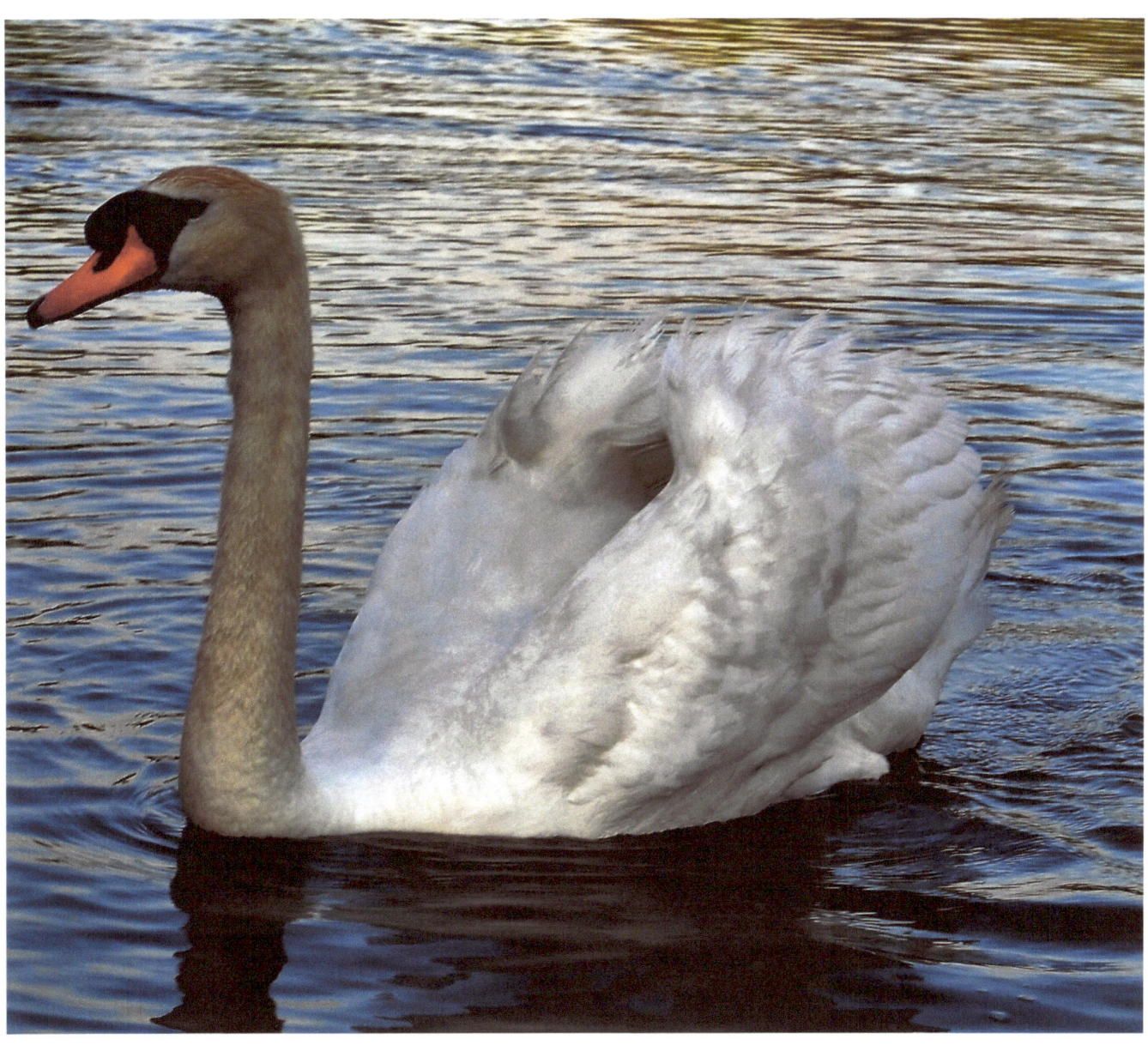

The Swan was sacred not only to the Druids, who saw it as representing the soul, and thought it able to travel between the mortal realm and the otherworld, but also to the Bards. In Irish mythology, Swans are usually depicted as shape-shifters, capable of transforming into human and bird form at will. They could be distinguished from normal Swans by the Gold or Silver chain which hung about their necks.

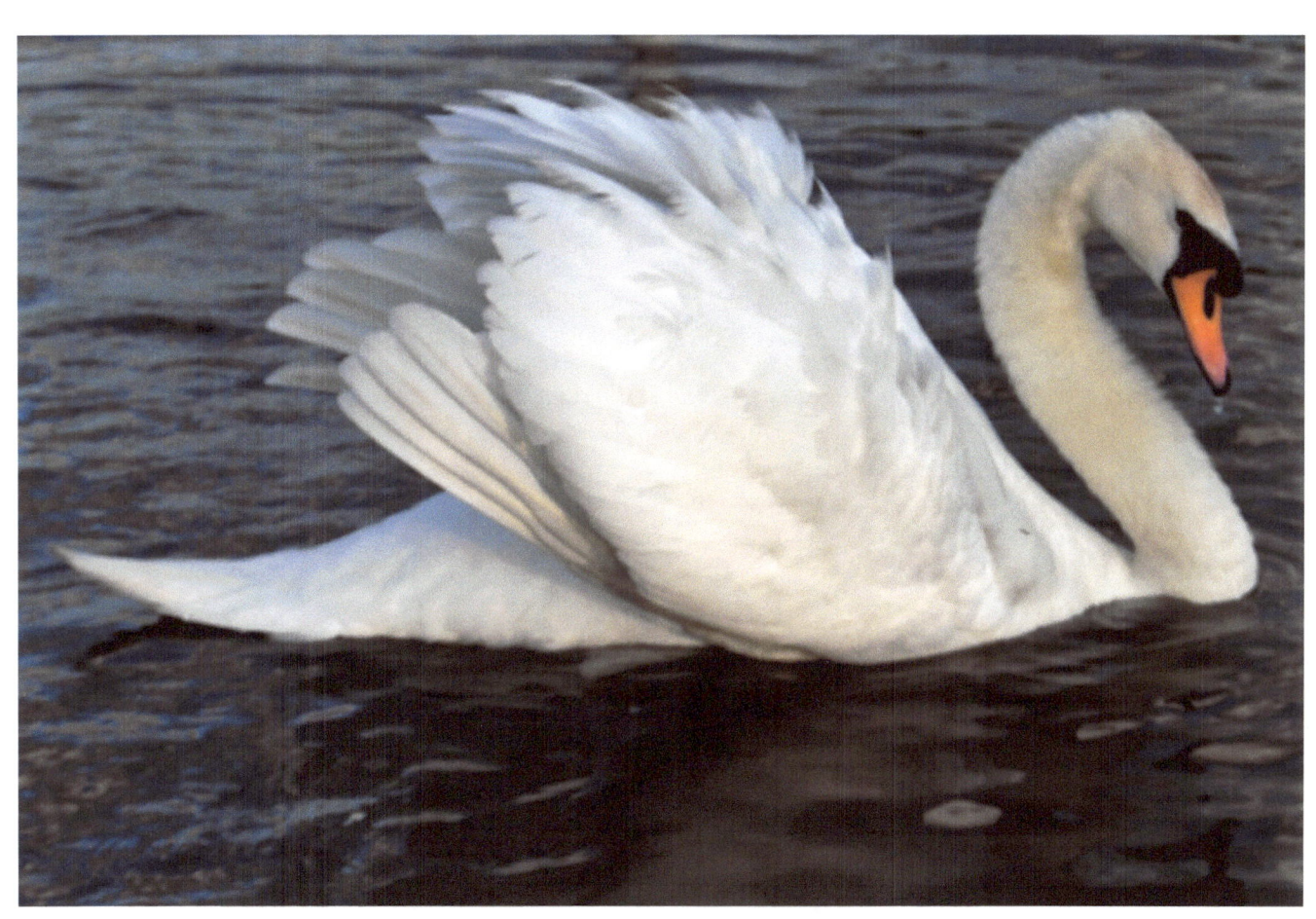

Classic neck and wing pose!

Swans are revered in Hinduism, and are compared to saintly persons whose chief characteristic is to be in the world without getting attached to it, just as a Swan's feather does not get wet although it is in water.

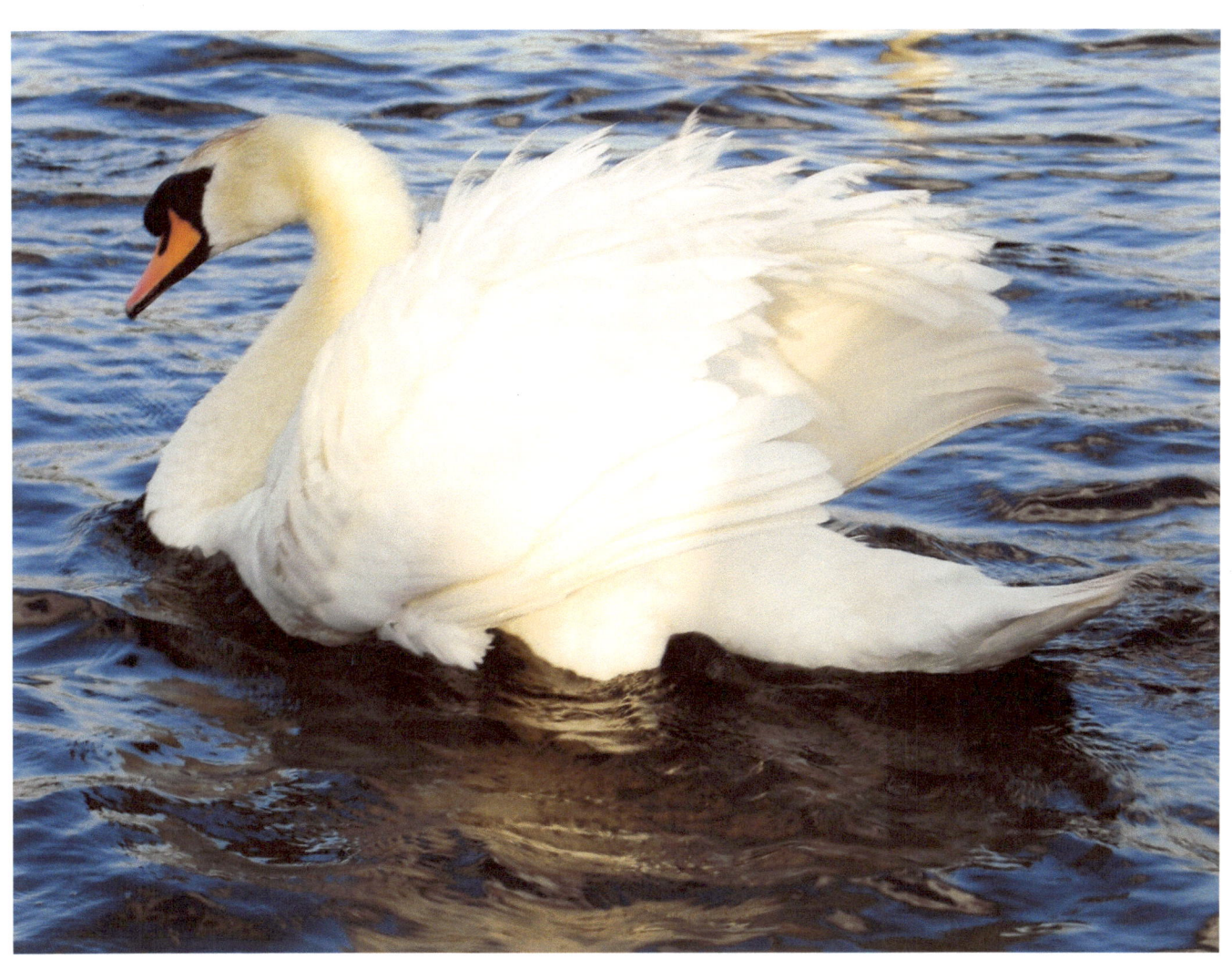

I can't get enough of those beautiful feathers!

The Sanskrit word for Swan is hamsa and the Hindi word is hansa, and the "Raja Hamsam" or the Royal Swan is the vehicle of Goddess Saraswati, and symbolises the "Sattva Guna" or purity par excellence.

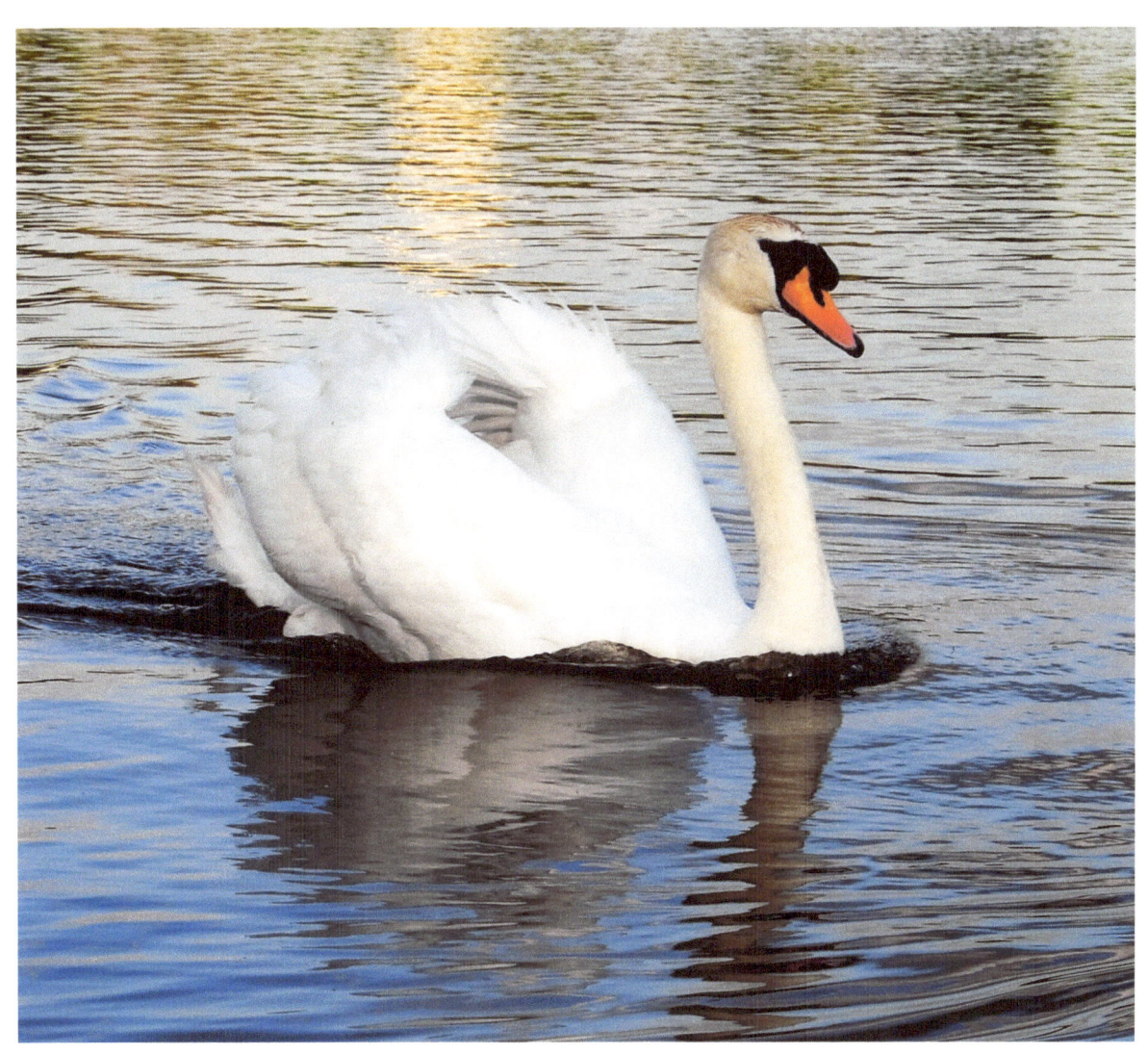

Gliding with ease!

In Vedic tradition, the Swan if offered a mixture of milk and water, is said to be able to drink the milk alone. Therefore, Goddess Saraswati the goddess of knowledge is seen riding the Swan because the Swan thus symbolizes "Viveka" i.e. prudence and discrimination between the good and the bad or between the eternal and the transient.

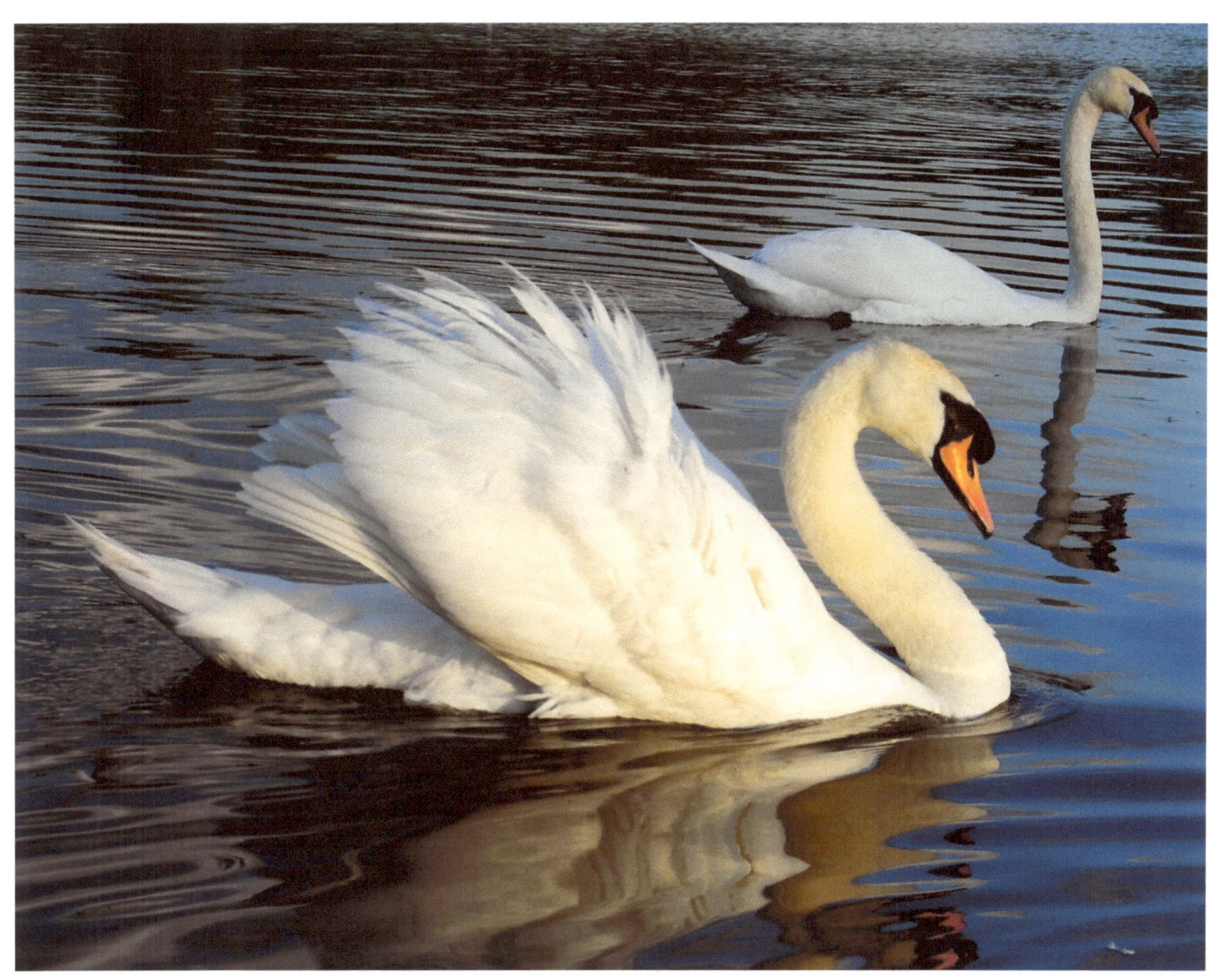

The couple again. Love those wings!

Several times in Vedic literature it mentions that persons who have attained great spiritual capabilities are called Paramahansa ("Supreme Swan") on account of their spiritual grace and ability to travel between various spiritual worlds. In the Vedas, Swans are said to reside in the summer on Lake Manasarovar and migrate to Indian lakes for the winter.

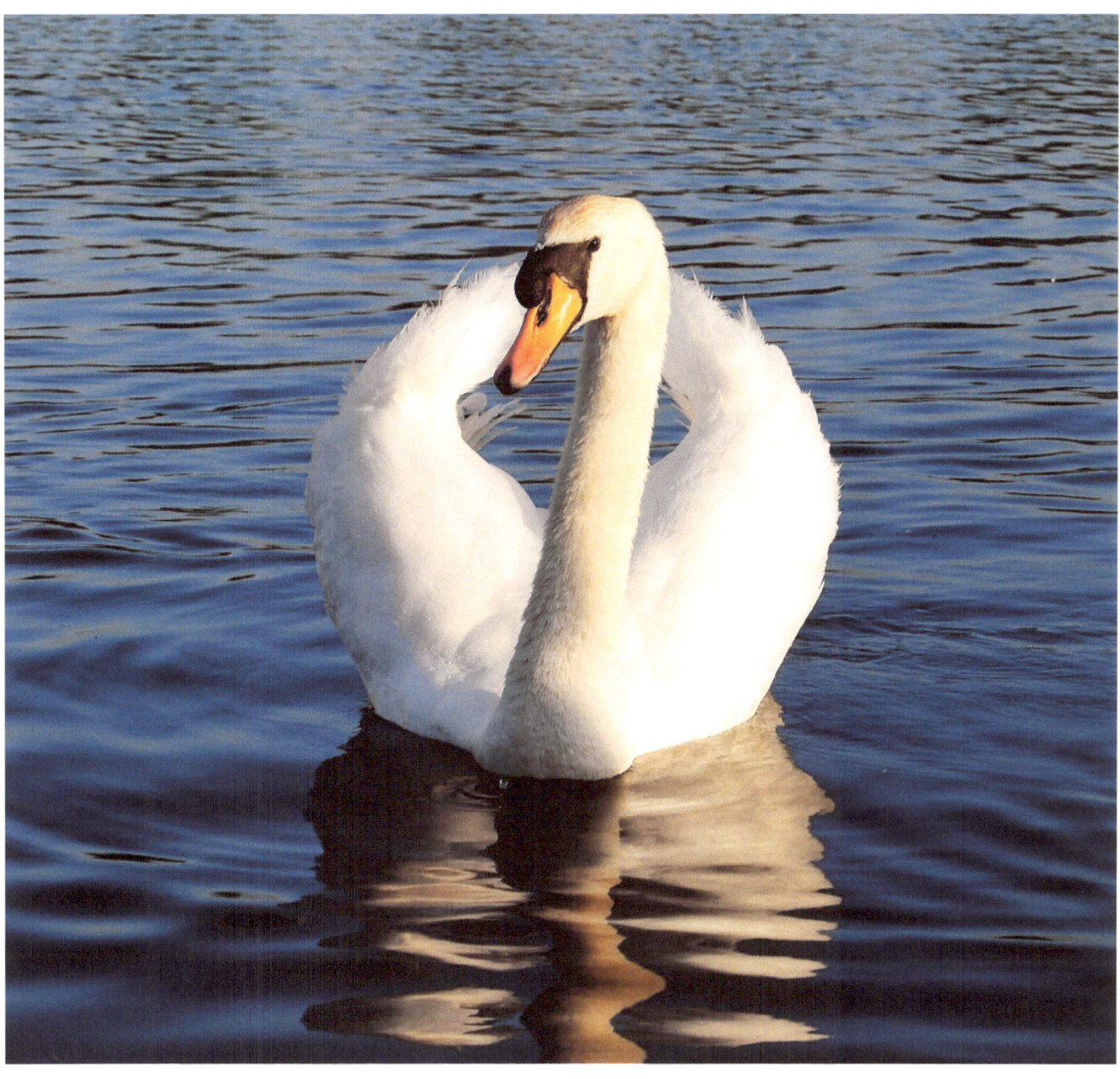

Leda and the Swan
W. B. Yeats

A sudden blow: the great wings beating still
Above the staggering girl, her thighs caressed
By the dark webs, her nape caught in his bill,
He holds her helpless breast upon his breast.
How can those terrified vague fingers push
The feathered glory from her loosening thighs?
And how can body, laid in that white rush,
But feel the strange heart beating where it lies?

A shudder in the loins engenders there
The broken wall, the burning roof and tower
And Agamemnon dead.
Being so caught up,
So mastered by the brute blood of the air,
Did she put on his knowledge with his power
Before the indifferent beak could let her drop?

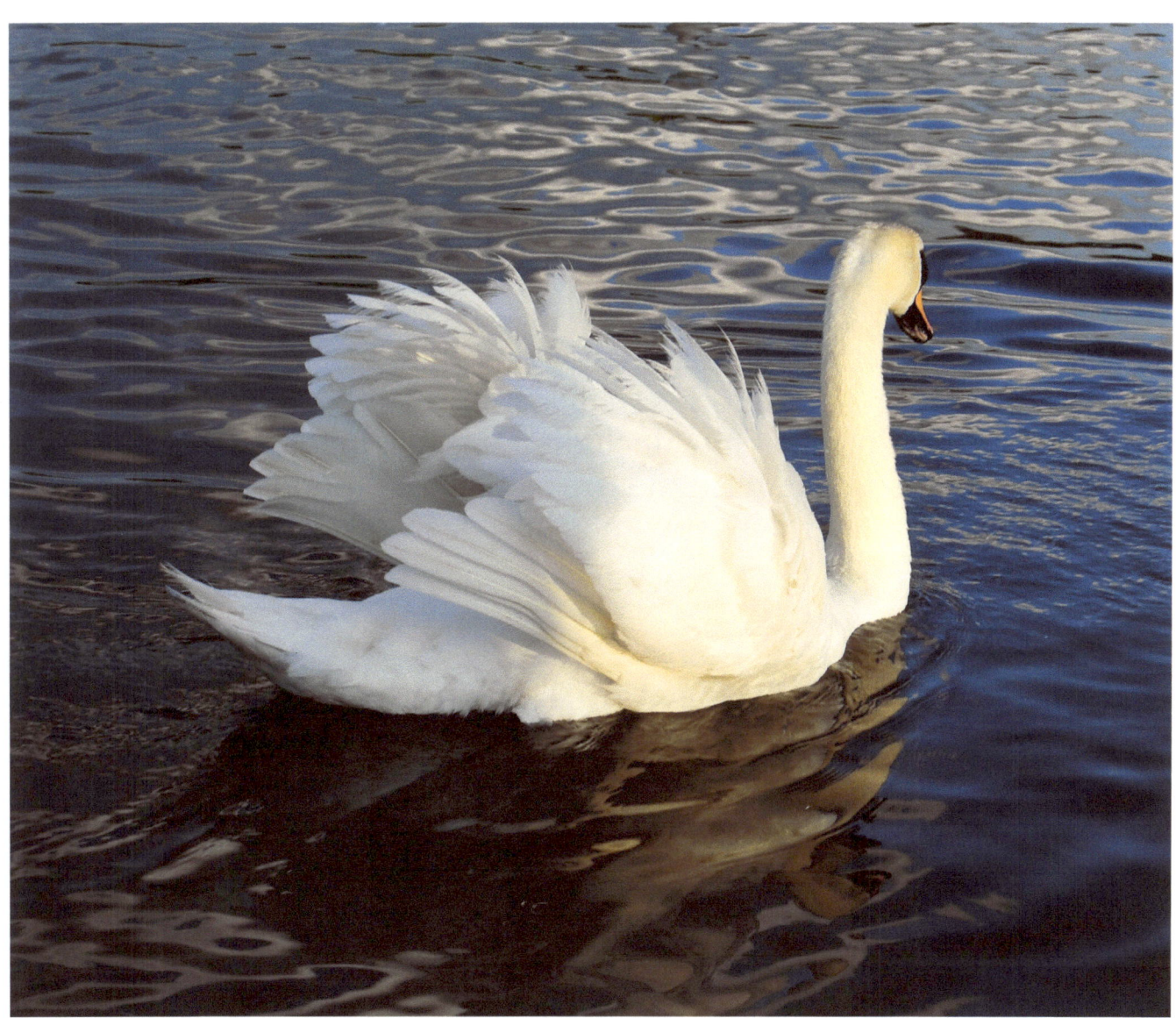

In Norse mythology, there are two Swans that drink from the sacred Well of Urd in the realm of Asgard, home of the gods. According to the Prose Edda, the water of this well is so pure and holy that all things that touch it turn White, including this original pair of Swans and all others descended from them. The poem Volundarkvida, or the Lay of Volund, part of the Poetic Edda, also features Swan maidens.

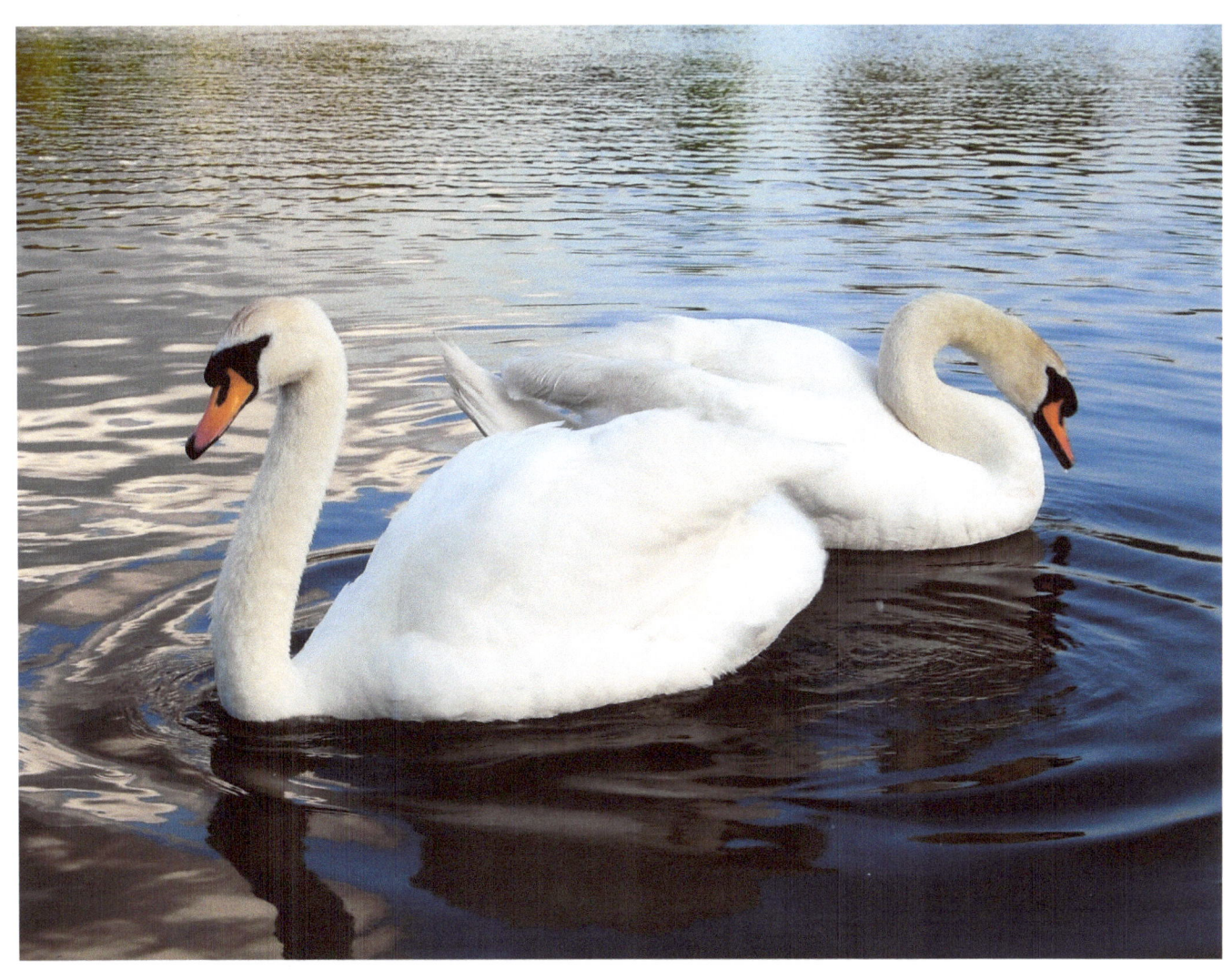

This couple was always together, all day.

To be born in a Duck's nest, in a farmyard, is of no consequence to a bird, if it is hatched from a Swan's egg.

~ Hans Christian Andersen, The Ugly Duckling

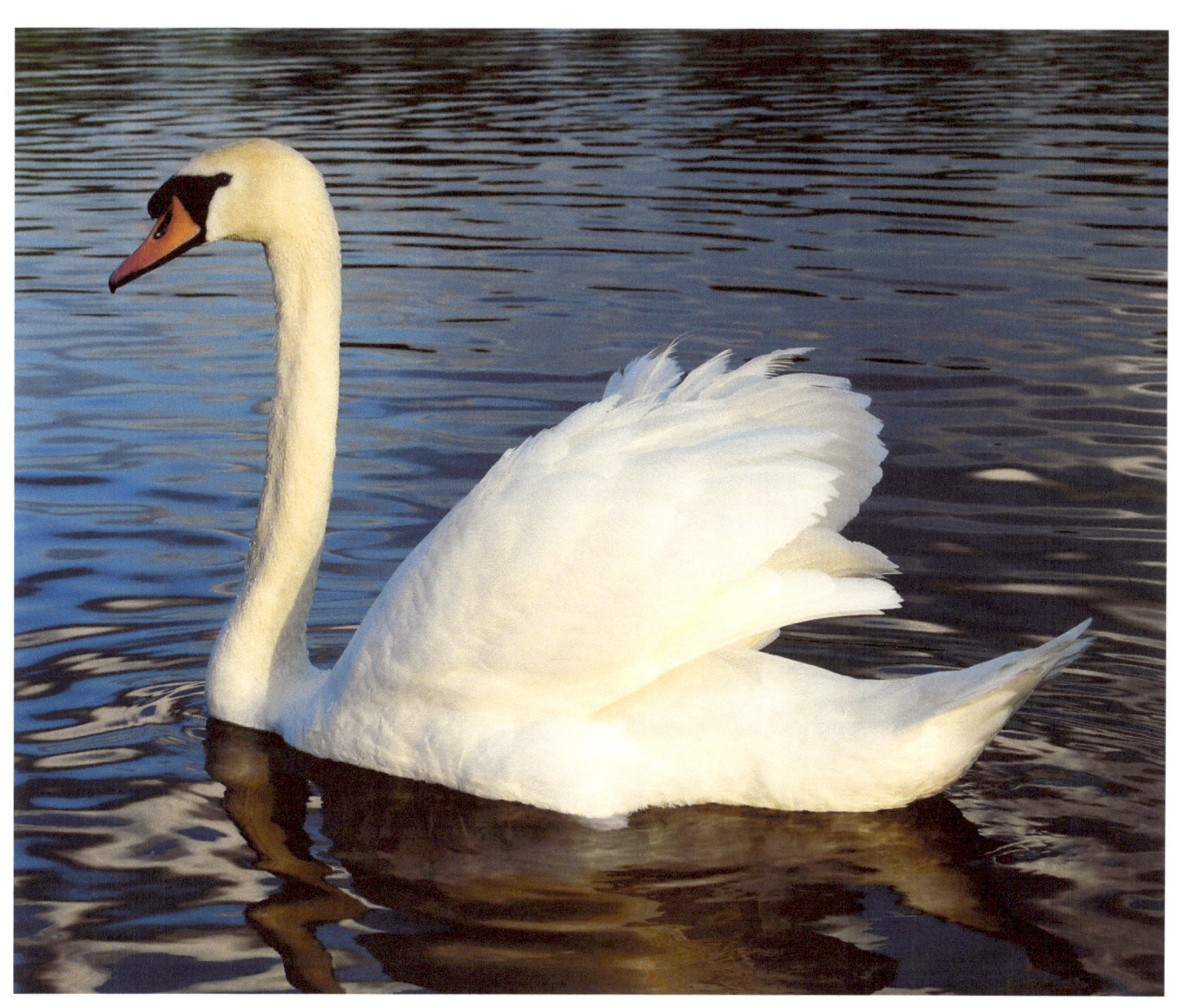

I've got my eye on you!

Swans are highly intelligent and remember who has been kind to them, or not.

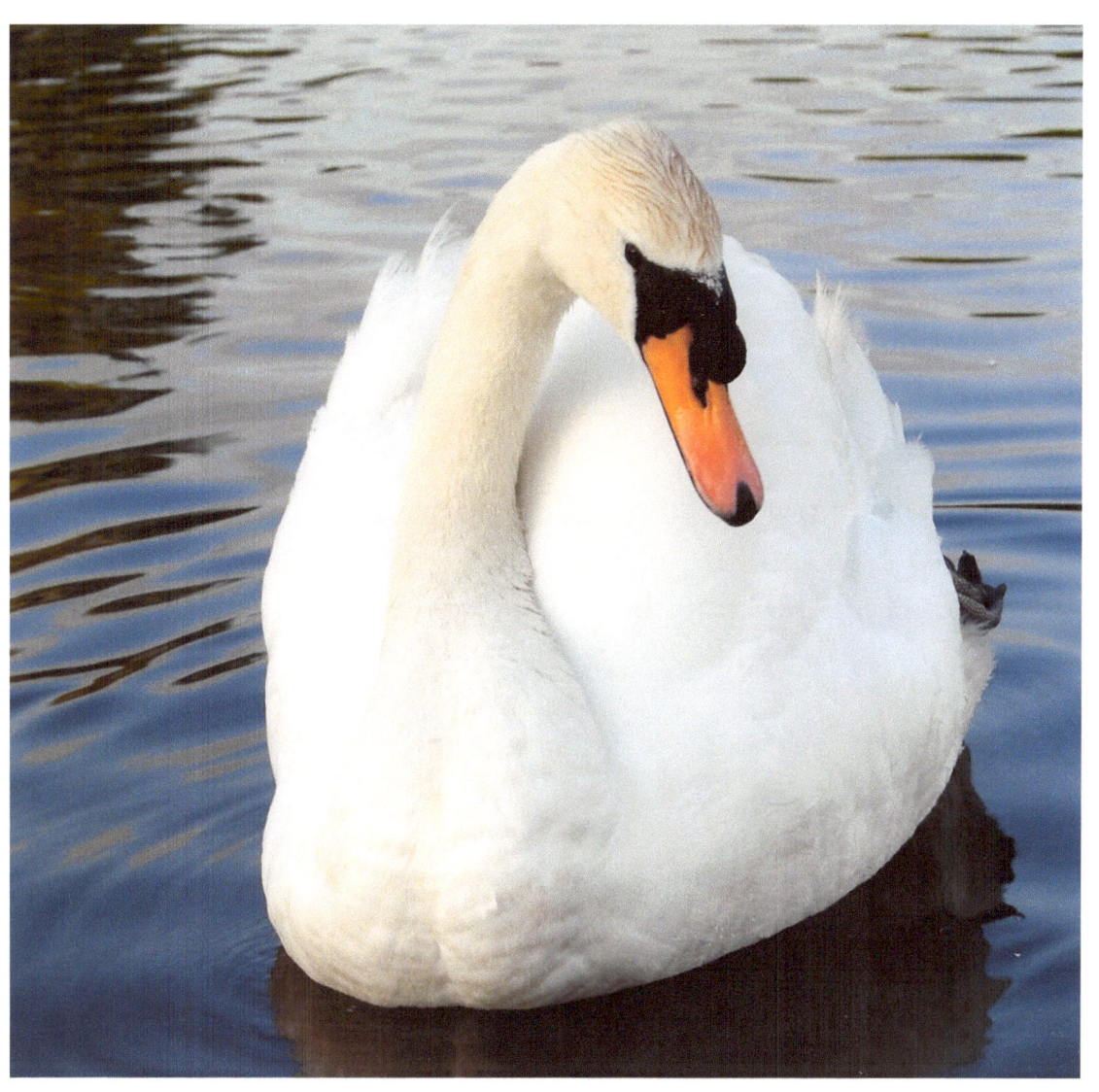

No fear! Just curiosity.

The Swan is known for its fierce temperament and its incredibly strong wings which are said to be able to cause dangerous (sometimes fatal) injuries to any animal the Swan feels threatened by. Swans can fly as fast as 60 miles per hour!

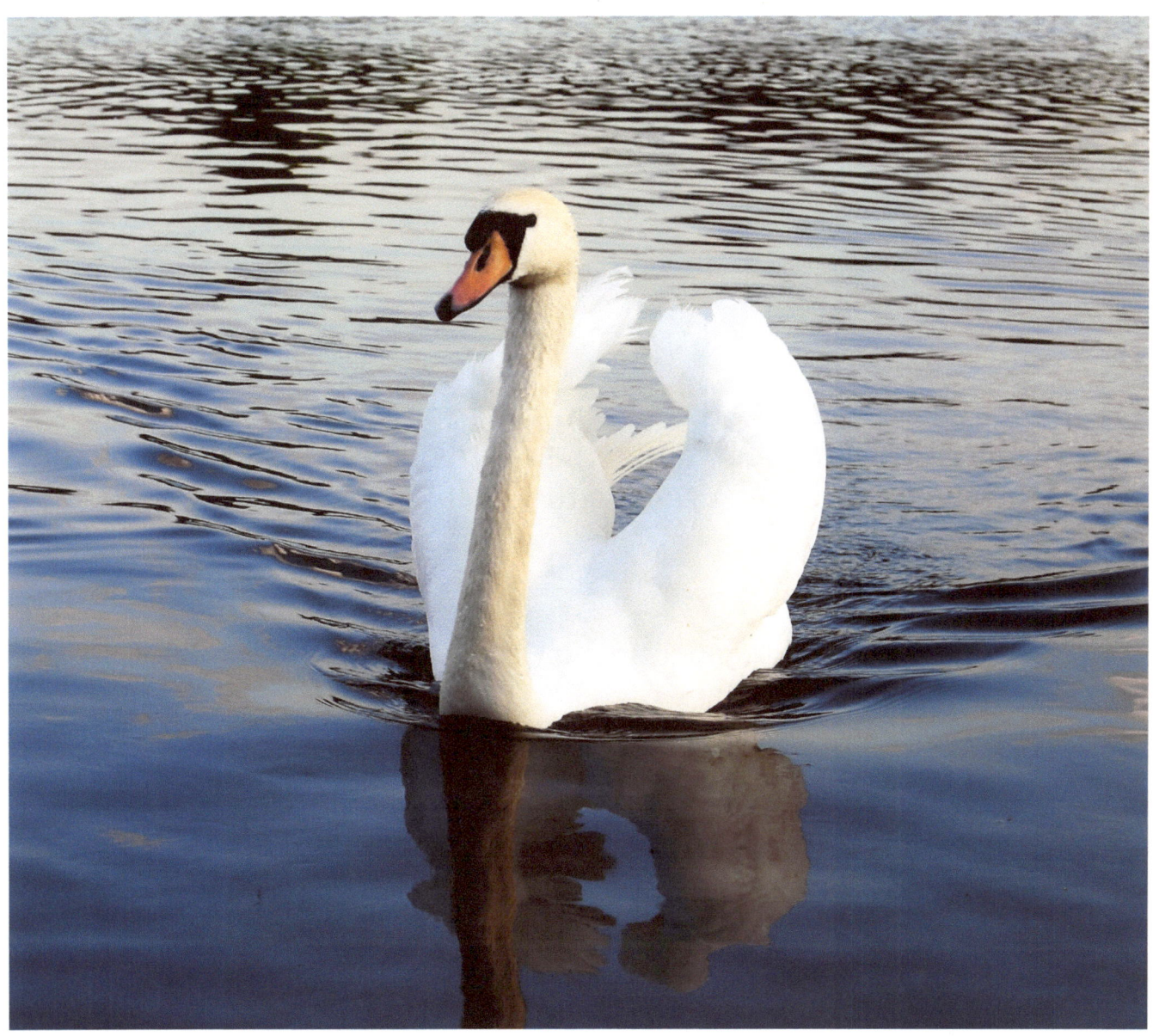

If you ever decide to feed a Swan, remember to throw their food directly onto the water, and not on the nearby land. This keeps Swans where they belong ~ in their safe, natural habitat.

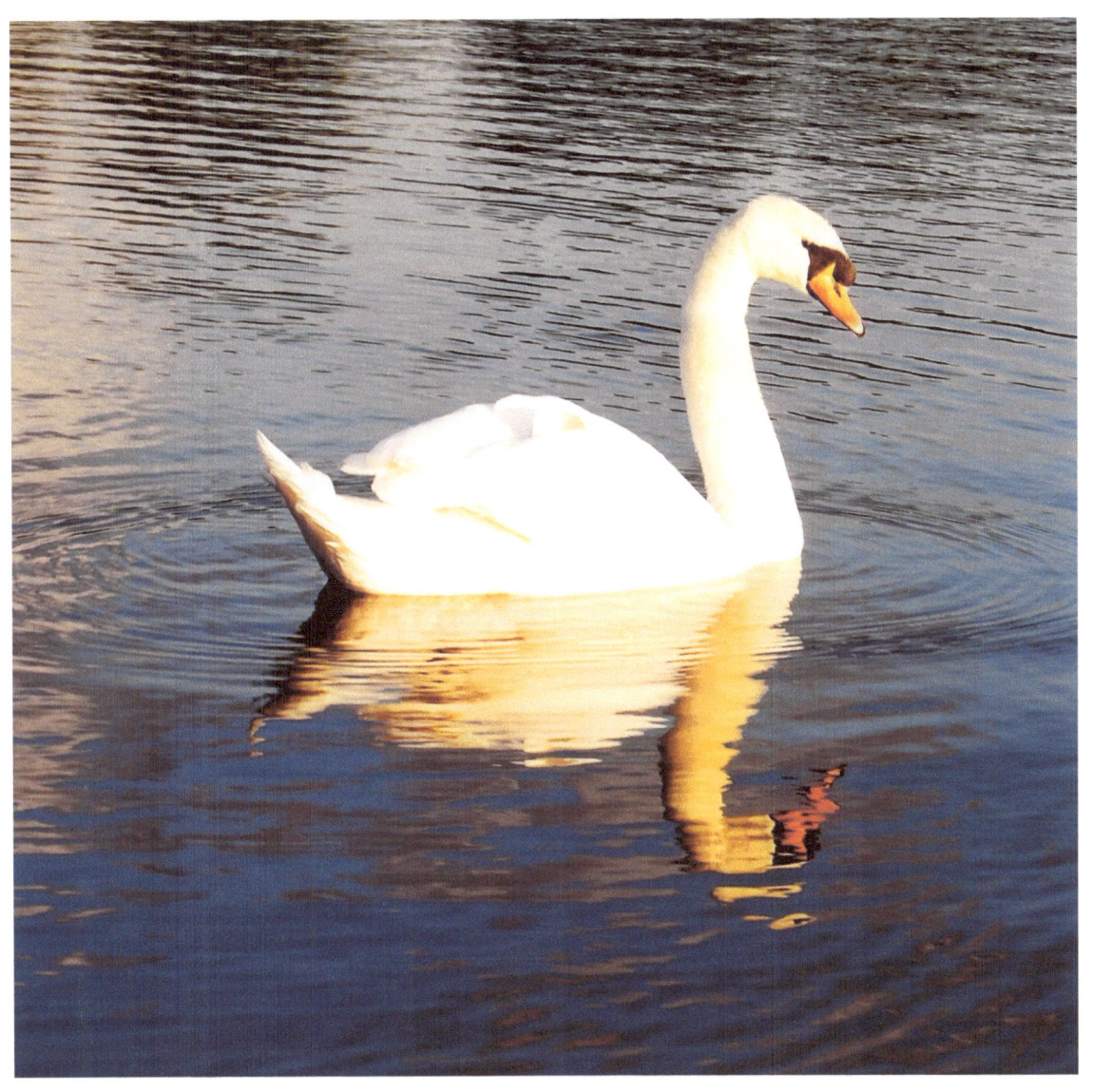

You can see the sunset colors starting on the lake here.

Swans, with graceful necks
Wings resembling Angel wings
Mystical and rare.

~H. Burns

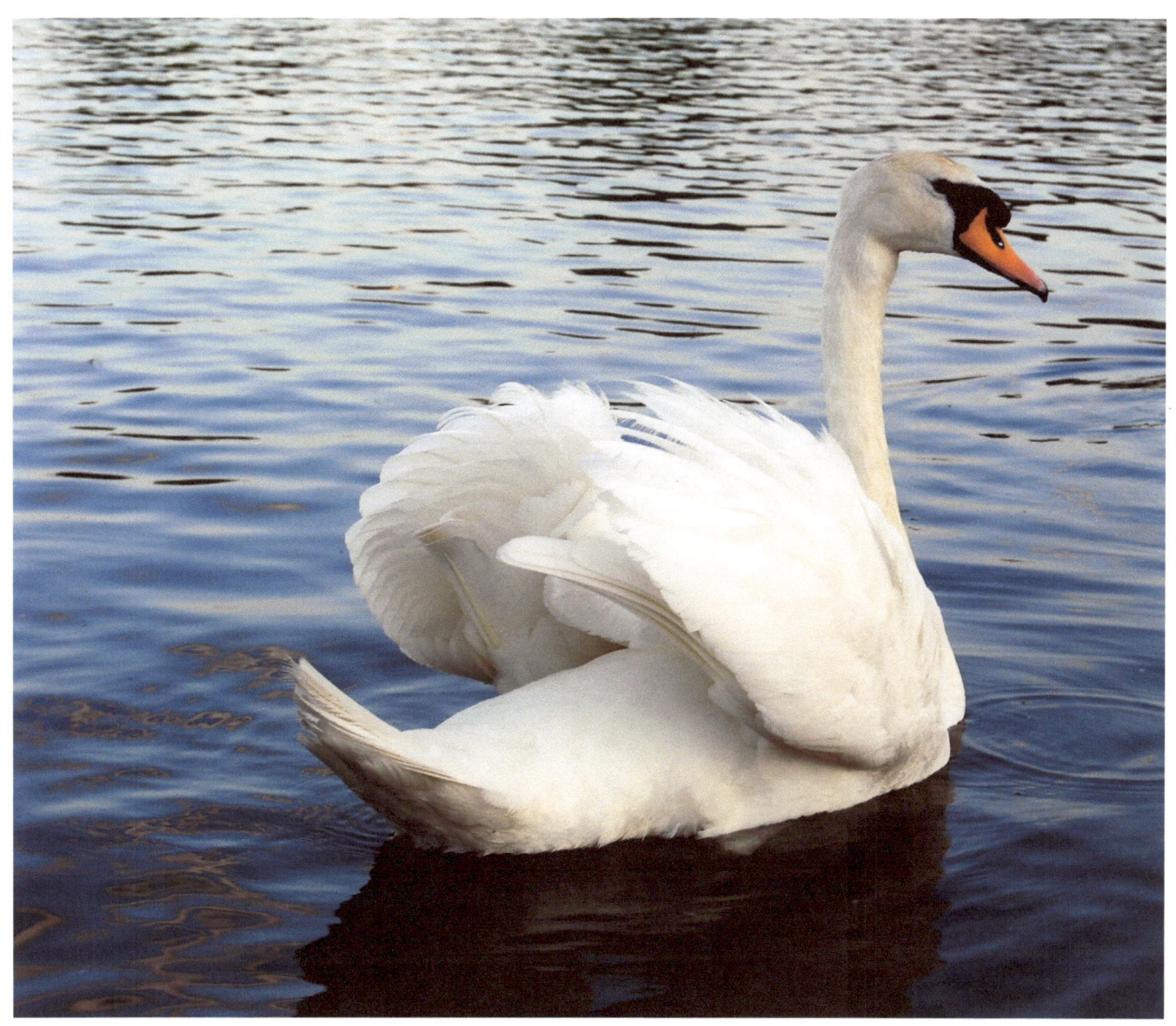

All of the Mute Swans in England and Wales are owned by the Queen of England! Not just the ones at Kensington Garden, but all the ones not privately owned, everywhere in the realm!

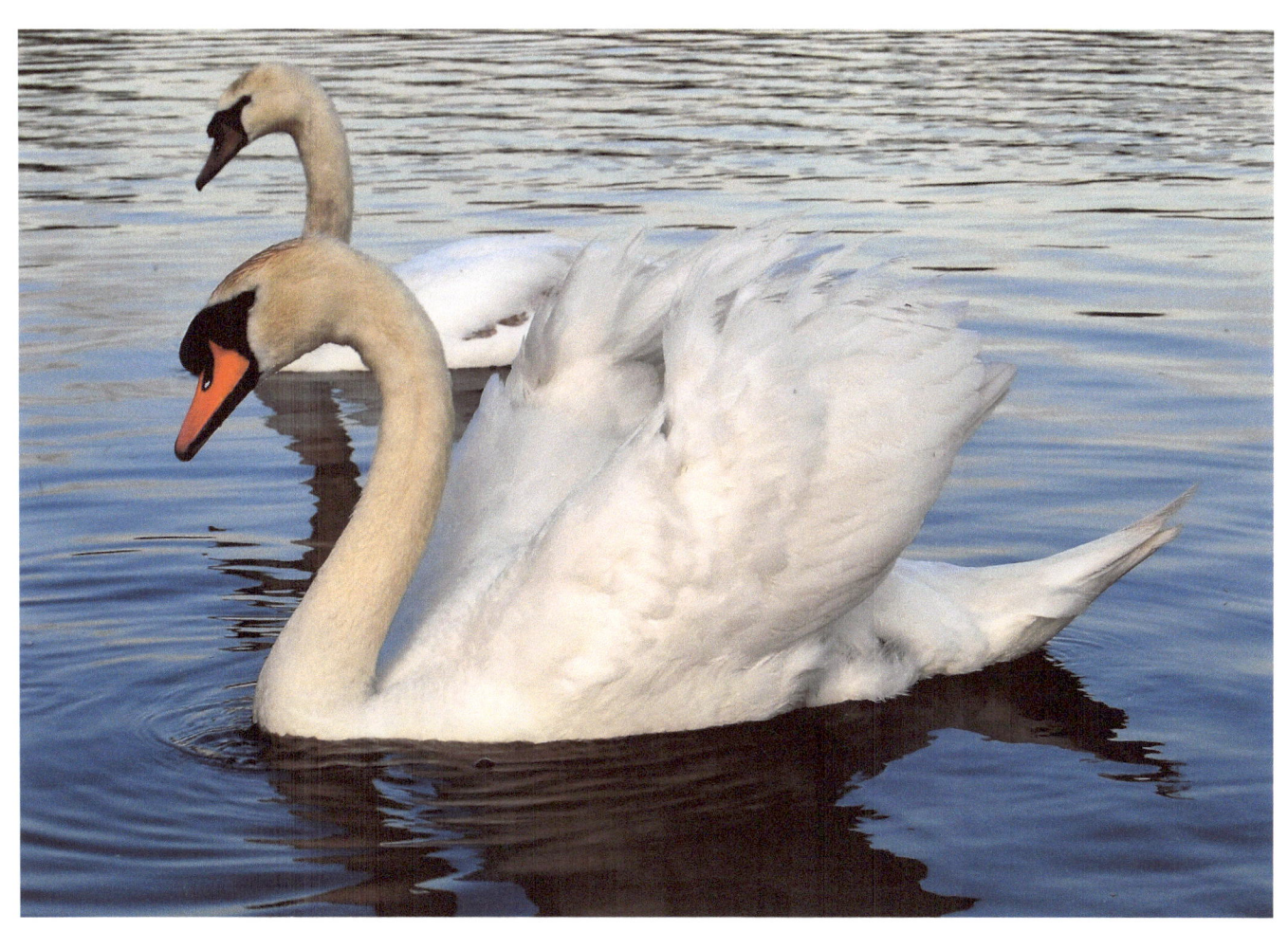

The couple again

In many cultures and mythologies, the Swan is associated with music, love, purity and the soul.

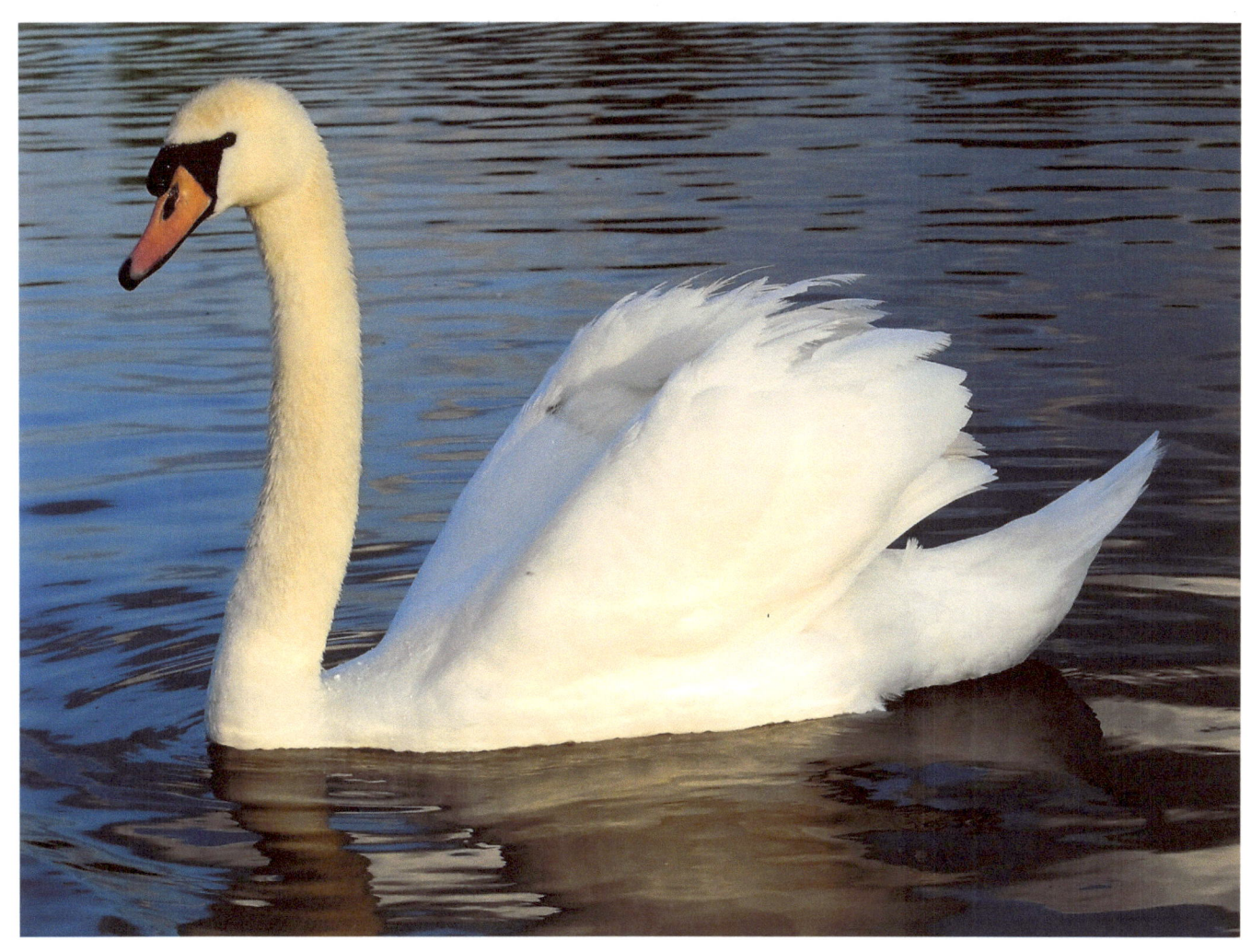

Watching me, on high alert!

Films and Plays With a Swan Theme

The Black Swan

Away and Back

Dance of the Little Swans

The Wild Swans

Swan Lake

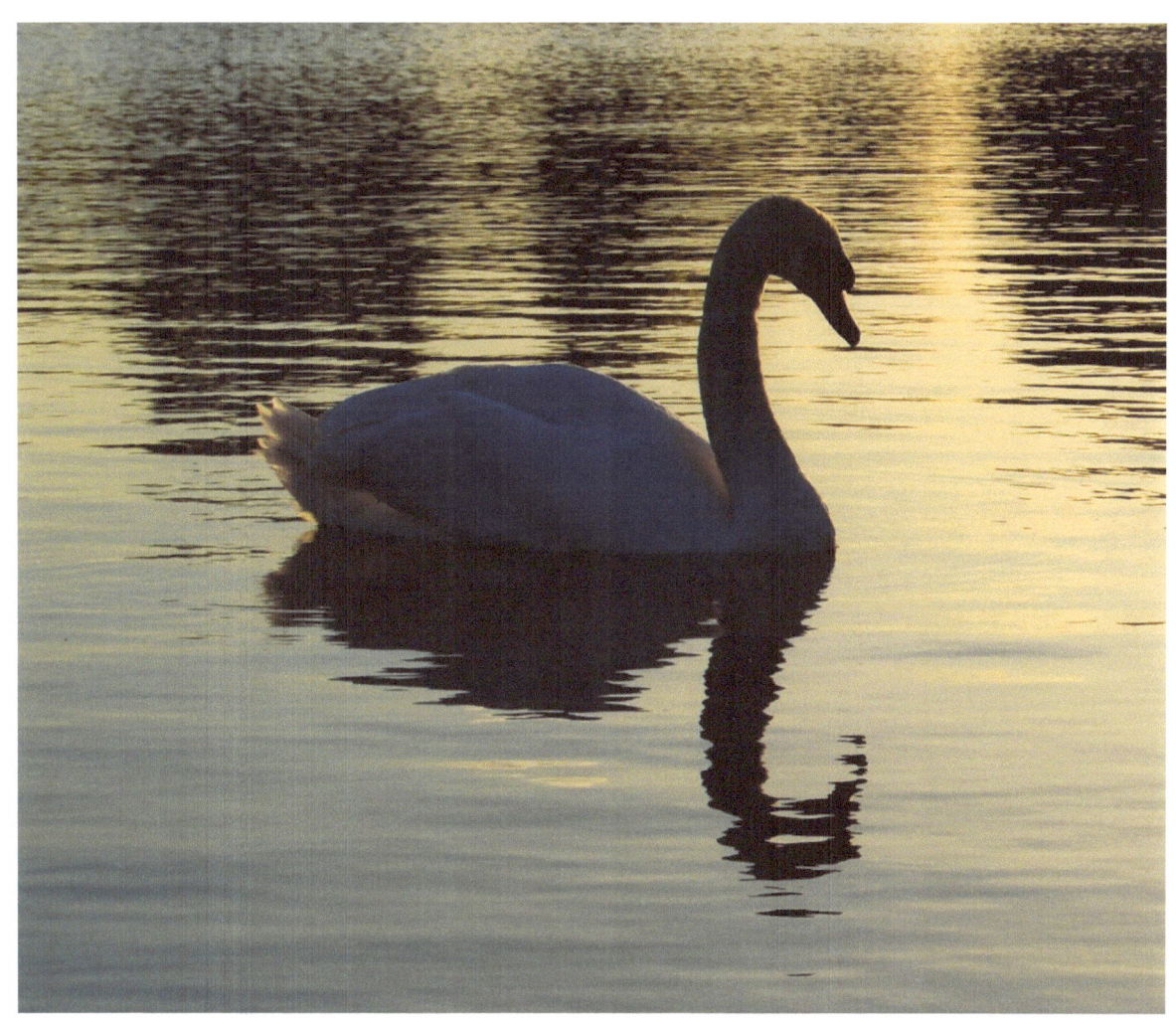

Late in the day, perfect silhouette.

Music Inspired by Swans

Sibelius: Symphony No. 5 (third movement)

Sibelius: The Swan of Tuonela

Gibbons: The Silver Swan

Saint-Saëns: The Swan

Orff: Carmina Burana (Olim lacus colueram)

Tchaikovsky: Swan Lake

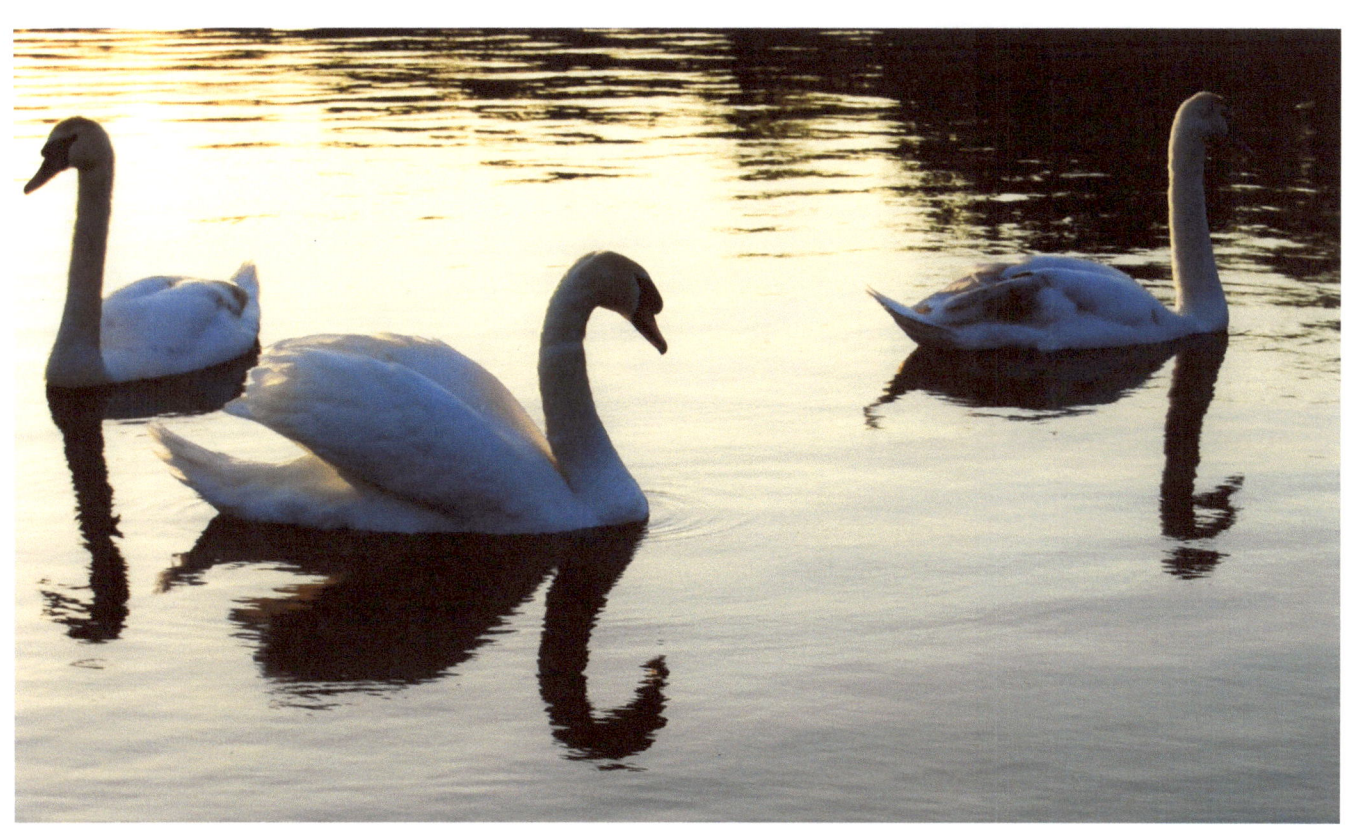

At dusk, the water is very calm and the Swans are too.

Novels Featuring Swans

The Trumpet of the Swan by E.B. White

Leonardo's Swans by Karen Essex

The Wild Swans, Three Daughters of China by June Chang

The Wild Swan Trilogy by Celeste De Blasis

The Black Swan by Mercedes Lackey

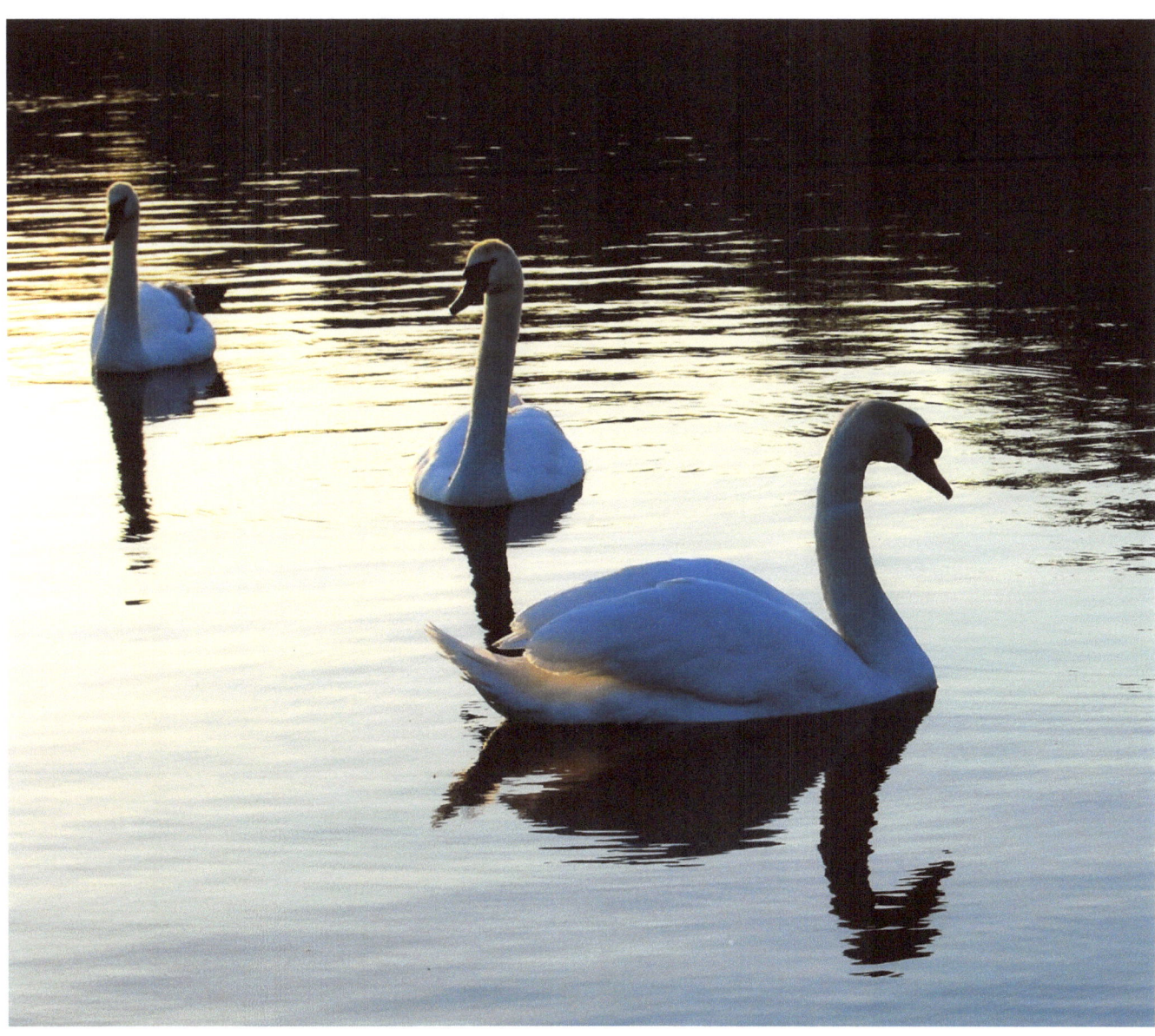

Fairy Tales Featuring Swans

The Wild Swans by Hans Christian Andersen

The Six Swans by the Brothers Grimm

The Swan Maidens by Joseph Jacobs

The Red Swan, old Indian Fairy Tale

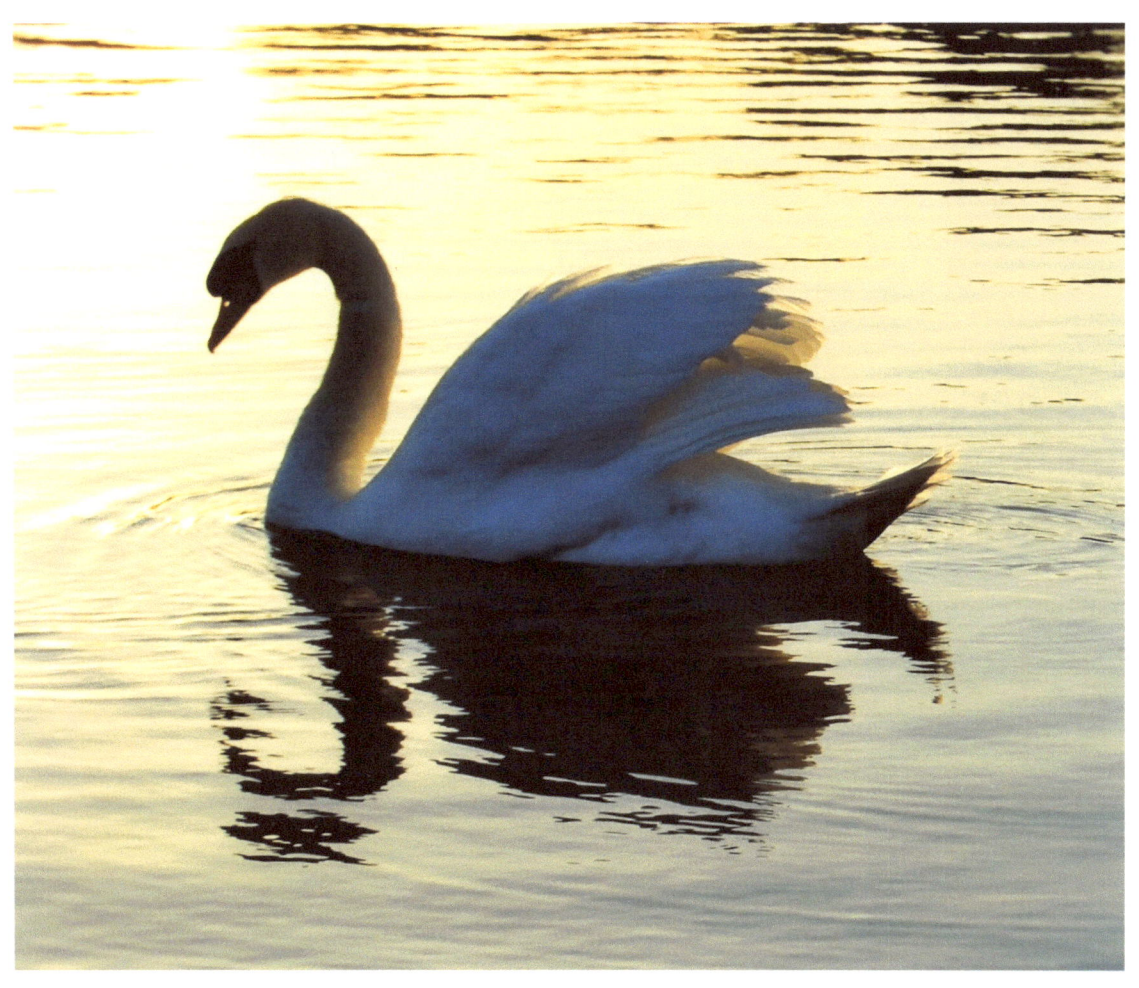
The golden light of dusk illuminates the pond and the Swans.

The Wild Swans at Coole
W. B. Yeats, 1865 – 1939

The trees are in their Autumn beauty
The woodland paths are dry,
Under the October twilight the water
Mirrors a still sky;
Upon the brimming water among the stones
Are nine and fifty Swans.

The nineteenth Autumn has come upon me
Since I first made my count;
I saw, before I had well finished,
All suddenly mount
And scatter wheeling in great broken rings
Upon their clamorous wings.
I have looked upon those brilliant creatures,
And now my heart is sore.

All's changed since I, hearing at twilight,
The first time on this shore,
The bell-beat of their wings above my head,
Trod with a lighter tread.

Unwearied still, lover by lover,
They paddle in the cold,
Companionable streams or climb the air;
Their hearts have not grown old;
Passion or conquest, wander where they will,
Attend upon them still.

But now they drift on the still water
Mysterious, beautiful;
Among what rushes will they build,
By what lake's edge or pool
Delight mens' eyes, when I awake some day
To find they have flown away?

Polish Knight Coat of Arms

www.ingramcontent.com/pod-product-compliance
Lightning Source LLC
Chambersburg PA
CBHW050737180526
45159CB00003B/1259